FIRST STEPS
SERIES
Painting
Watercolors

CATHY JOHNSON

NORTH LIGHT BOOKS
Cincinnati, Ohio

Painting Watercolors. Copyright ©1995 by Cathy A. Johnson. Printed and bound in Hong Kong. All rights reserved. No part of this book may be reproduced in any form or by any electronic or mechanical means including information storage and retrieval systems without permission in writing from the publisher, except by a reviewer, who may quote brief passages in a review. Published by North Light Books, an imprint of F&W Publications, Inc., 1507 Dana Avenue, Cincinnati, Ohio 45207. 1-800-289-0963. First edition.

Other fine North Light Books are available from your local bookstore, art supply store or direct from the publisher.

99 98 97 96 5 4 3 2

Library of Congress Cataloging-in-Publication Data

Johnson Cathy (Cathy A.)
Painting watercolors / by Cathy A. Johnson.—1st ed.
 p. cm. — (First steps series)
 Includes bibliographical references and index.
 ISBN 0-89134-616-3 (pb)
 1. Watercolor painting—Technique. I. Title. II. Series: First steps
 series (Cincinnati, Ohio)
ND2420.J63 1995
751.42′2—dc20 95-6084
 CIP

Edited by Greg Albert
Designed by Brian Roeth

METRIC CONVERSION CHART		
TO CONVERT	**TO**	**MULTIPLY BY**
Inches	Centimeters	2.54
Centimeters	Inches	0.4
Feet	Centimeters	30.5
Centimeters	Feet	0.03
Yards	Meters	0.9
Meters	Yards	1.1
Sq. Inches	Sq. Centimeters	6.45
Sq. Centimeters	Sq. Inches	0.16
Sq. Feet	Sq. Meters	0.09
Sq. Meters	Sq. Feet	10.8
Sq. Yards	Sq. Meters	0.8
Sq. Meters	Sq. Yards	1.2
Pounds	Kilograms	0.45
Kilograms	Pounds	2.2
Ounces	Grams	28.4
Grams	Ounces	0.04

Dedication

To my students and readers, whose intelligent questions have helped to shape this book; to my brother-in-law, watercolorist Richard Busey, for reminding me what to say; to Greg Albert, my supportive and meticulous editor; and to David Lewis, who kick-starts it all; and to Harris, whose presence makes it all possible.

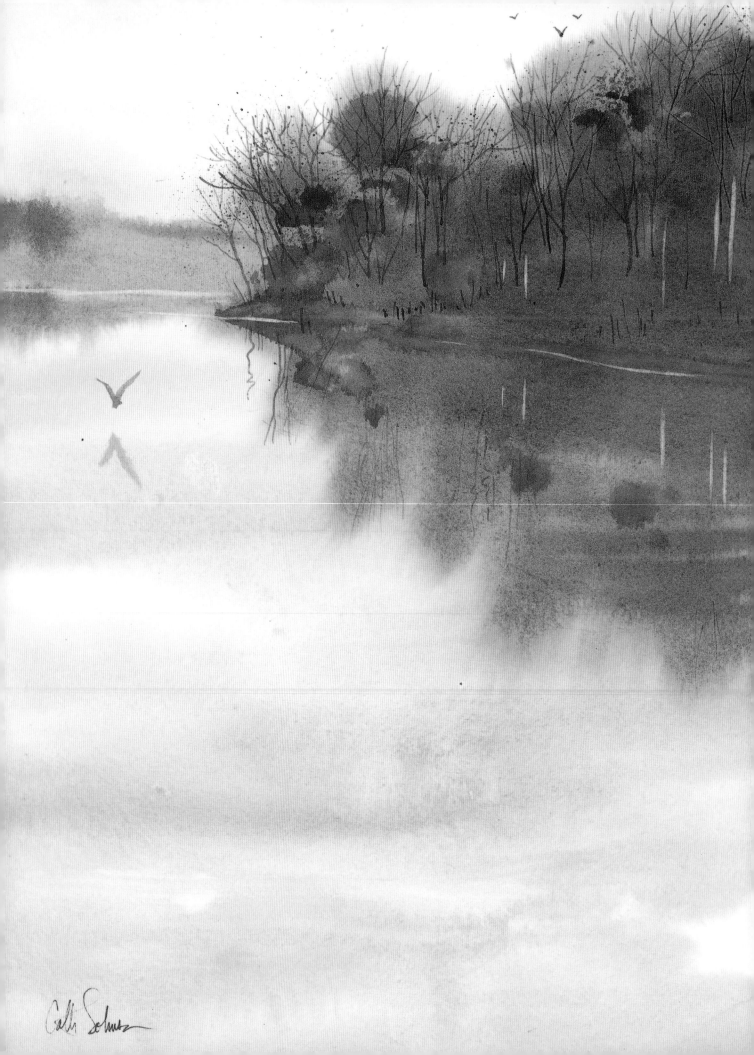

Table of Contents

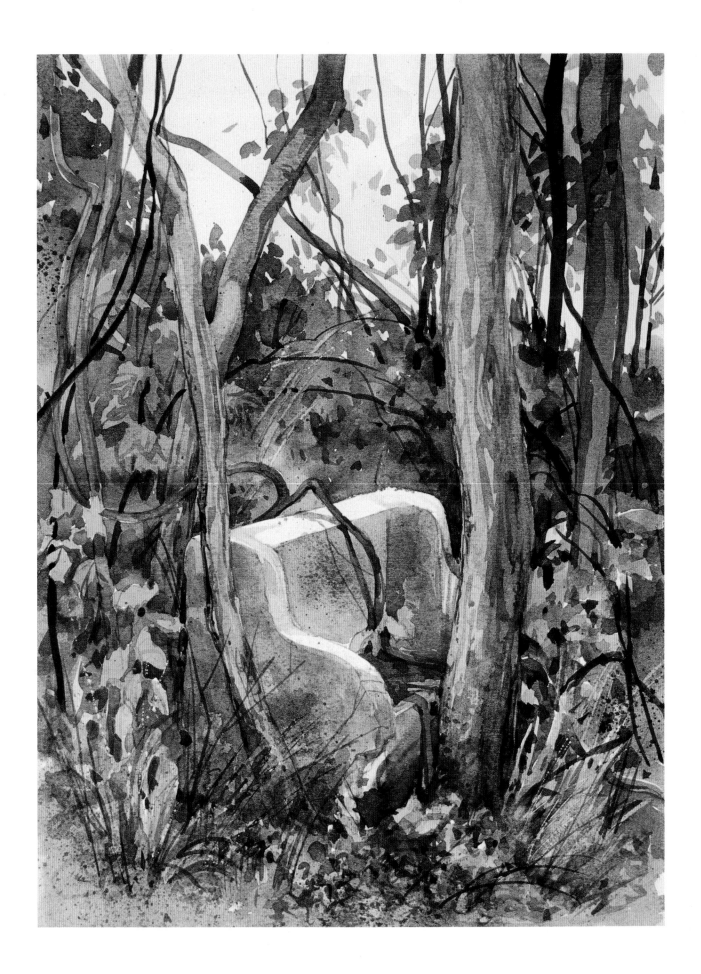

Introduction

Why does watercolor inspire such passion and loyalty? Here are ten good reasons:

One, it *is* fresh. Watercolor has a glow that no other medium can match.

Two, watercolor is wonderfully transparent. It can capture light as can no other medium.

Three, watercolor is versatile. It can be loose and free, or as full of crisp details as a photograph; it can be pastel and soft, or strong and bold.

Four, watercolor is quick. Fast mixing, fast blending, fast *drying*— it's that very quickness that encourages swift handling (and those fresh effects).

Five, watercolor is convenient. There's no need for messy mediums or elaborate preparations.

Six, it's reasonably inexpensive—or it can be. Your setup doesn't have to cost the crown jewels.

Seven, the necessary materials are available just about anywhere— at art supply stores, by mail, even at discount stores.

Eight, watercolor is clean. Cleanup is a snap; brushes come clean with a swish through the water bowl. There's no telltale odor of turpentine or layer of pastel dust on the floor.

Nine, watercolor is portable. You can carry enough supplies to do a full-fledged painting (or several of them) in a backpack.

Ten, watercolor is unpredictable. That may sound like a minus to you if you're just starting out, but it's also exciting. You'll never be bored or complacent.

Intrigued? Ready to jump in and test the water—and the water*color*? You can do it—and I'll show you *how*.

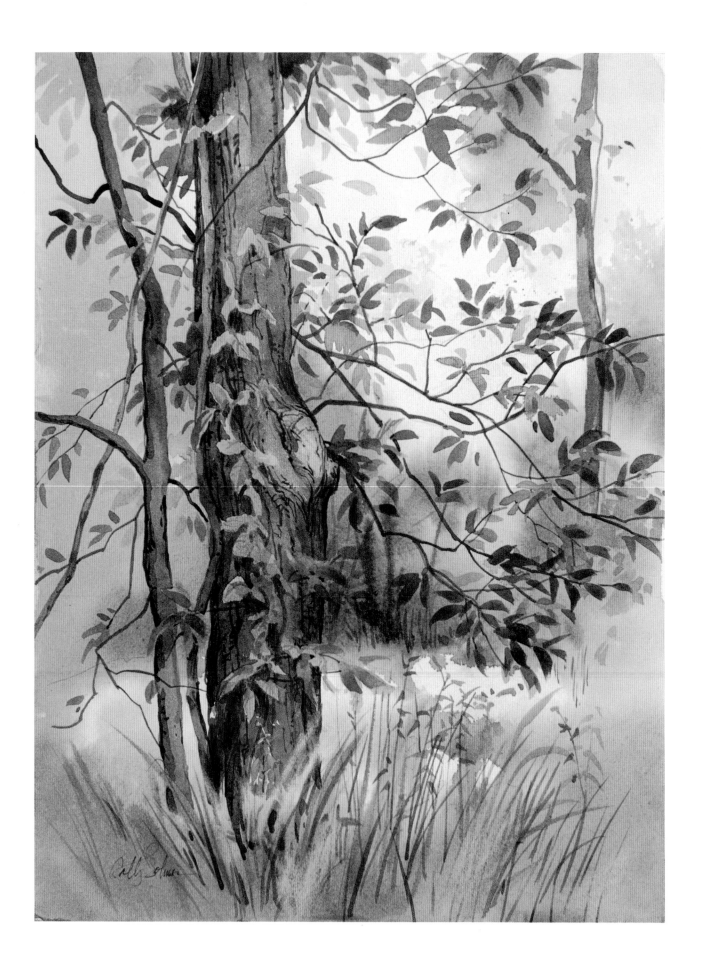

Chapter One

GETTING STARTED

Getting started with a new medium is exciting—watercolor makes it more so. Where do I start? What do I need to buy? What kind of brushes are basics, and do they have to be expensive? (They don't.) What colors do I need? What's really a necessity and what's not? And what do all those strange words mean? (In fact, every job, every hobby, every aspect of our lives has its own special set of words to describe what we're doing.)

TIP

Watch for our **Watercolor Dictionary** *throughout this book— when an unfamiliar term comes up, we'll define it right away to let you in on the lingo. Our dictionary acts as a brief introduction to those colorful terms that describe the things—like* **washes** *and* **puddles***—you'll be doing with ease after a little practice.*

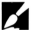 **Watercolor Dictionary: Wash**

To show you how it works, we'll jump right in with a definition of *wash.* A wash is any area of pigment and water that you apply to your paper. This can be quite large (a sky wash, for instance) or as small as an individual brushstroke. It may be flat or graded (graduated from light to dark or vice versa, or from color to color).

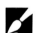 **Watercolor Dictionary: Puddle**

Another word we usually understand in a different context. A *watercolor puddle* is an extremely wet wash that's allowed to dry without touching it; it develops hard edges, but relax—you want them here. See the how-to section for more information on puddles.

What's the Best Way to Start?

The best way is to *want* to paint in watercolor—motivation, inspiration, whatever it takes. Then, get a basic set of painting gear together—and I do mean basic. Take it easy on yourself and your budget. Test the waters first to see if you even *like* the medium.

Be gentle with yourself. Don't expect to produce a masterpiece your first time out (or your tenth). And don't expect to **pull a wash** perfectly the first time out. It's like any other skill; it takes a bit of work—a bit of practice—along with the fun. But trust me, it's worth it.

Be gentle with yourself. You won't produce a masterpiece the first time you paint.

Watercolor Dictionary: Pull a wash

Refers to the way you start at the top of a wash (sometimes on a slightly tilted surface to help the paint flow down the paper). With each new brushstroke, you add more water and pigment, catching the bottom edge of the previous stroke and *pulling* the wash down the page. (Similar phrases are "put down a wash," and "float a wash"—same thing.)

Where and When to Paint

One of the lovely things about watercolor is that since it is so portable and lightweight, you can paint almost anyplace. Just try to get as comfortable as you can. Don't overlook the subjects close at hand—your own garden, a potted plant on the windowsill, your pets, family, friends.

When to paint is any time you feel the spirit move you—but do make sure you're not too tired or pressured. That's a sure recipe for frustration, and the idea is to *enjoy* yourself.

Inspiration is nice, but sometimes diligently exploring the basics, mood or no mood, will take you a lot farther down the road to a decent painting. Try to paint some each day, even if you do just a quick sketch.

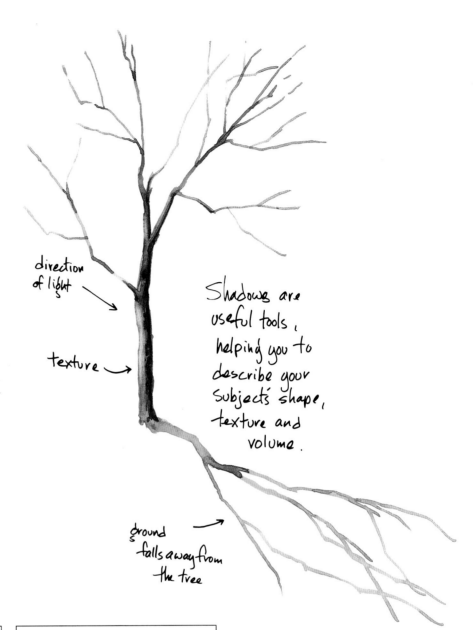

direction of light

texture →

Shadows are useful tools, helping you to describe your subject's shape, texture and volume.

ground falls away from the tree

TIP

Set an appointment with yourself—every Sunday afternoon; Thursday evening while the kids go to soccer practice; on your lunch break; whatever. Paint when you have a block of time—be it fifteen minutes or three days. Just try to make sure you won't be interrupted, if possible—a watercolor wash interrupted in the middle can result in hard edges and unwanted effects.

TIP

Time of day affects not only your mood or your creative juices (are you a night person or a morning person?), but also how your subject matter looks. The light is lovely in the morning or late afternoon; long shadows run away from objects, following the shape of the ground. Textures and shapes are defined or accented. The flatter shadows of high noon aren't as interesting as the more slanting rays of the end of the day.

The First Materials to Buy

There's a wonderful array of equipment, tools and gadgets out there, all designed to make it easier for you to paint in watercolor. What's a necessity and what's not is up to you, once you know your way around a paintbox. But what you need to get *started* is gratifyingly simple. We'll show you what you need to begin painting in watercolor and offer several options to let you try on the approach that's most comfortable to *you*. We'll discover what the various paper weights and surfaces—*rough, cold-press* (a medium-textured surface), and *hot-press* or *plate* (smooth)—mean and how they act, and we'll play with brushes.

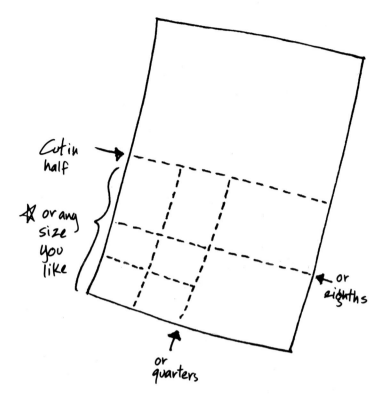

Tooling Up

The *most* basic supplies for watercolor are paints, paper, brushes, a water container and a palette. The ones you choose can make the difference between enjoying your work or not. Here is a basic supply list—these are generally considered typical watercolor necessities. Some of these you'll use, some you won't. There may be others you discover along the way, as well.

Paper
Paints
Brushes
Painting support
Palette
Water Container
No. 2 Pencil
Soft Eraser
Masking or Drafting Tape
Paper Towels, Tissues or Rags
Liquid Mask
Rubber Cement Pickup

If you find that you prefer to paint big, splashy paintings, a teeny, tiny field box with a few half pans and a no. 4 brush will drive you crazy. If, on the other hand, you have limited space, you like to keep things manageable, and you are most comfortable working on a smaller scale, you won't need the huge inch-wide brushes and full-sized paper supports. Look over our list of basics and choose what's best for you.

Paper

It isn't necessary to paint full-sheet size (approximately 22″ × 30″). And besides, face it—you *are* going to waste some paper. Nobody gets through the learning stage without throwing away a lot of false starts. I call these "practice runs" and consider them a learning experience.

Consider cutting the big, full sheets in half or in quarters, or buy a watercolor pad or block of the size you want while you learn your way around.

TIP

I find that 140-lb., cold-press paper meets most of my needs, is easiest to handle, and is often less expensive than the heavier paper or more exotic surfaces—you can't go wrong!

If price is a consideration, working smaller lets you get by with smaller, less expensive brushes; small, less expensive palettes; and smaller amounts of paint.

If you prefer, you can buy paper in a spiral-bound pad, a hardbound sketchbook or a block. Blocks come in sizes from 4″ × 6″ to 18″ × 24″ or larger, allowing plenty of versatility, though you may find that the larger-sized blocks buckle more than you like before drying flat again.

There are three types of watercolor paper available: *hot-press, cold-press* and *rough*, which refer to surface texture. This texture is created during

Rough Paper...

Dry-brush is easy on rough.

Notice how smooth this wash on rough paper is

Cold-Press....▶

Paint still goes on relatively smoothly on cold-press paper.

Dry-brush effects are more subtle

Paint settles and puddles in fresh (and frustrating) ways.

◀Hot-Press...

"Backruns" and "flowers."

Dry-brush is more difficult—it depends more on brushwork than paper surface.

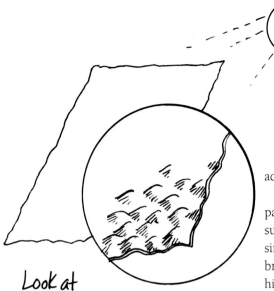

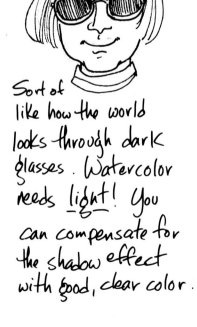

Look at rough or cold-pressed paper in strong diagonal light—you can see shadows that may "gray" your painting slightly.

Sort of like how the world looks through dark glasses. Watercolor needs light! You can compensate for the shadow effect with good, clear color.

the manufacturing process, and it is determined by the coarseness of the metal screen the paper is dried on as well as *how* it is dried. (Is it air dried as is? Weighted down? Pressed with heat added?)

Many watercolorists prefer *rough* paper. In practice, the rough paper's surface makes texturing relatively simple; you can run an almost-dry brush over the surface of the little hills, just touching their peaks, to suggest any number of effects. (Those effects, however, will be dictated by the texture of the paper itself.)

Oddly enough, it is easier to do a smooth wash on most rough papers than on any other option you may choose (see chapter two). The color kind of averages itself out in all those little valleys.

Versatile *cold-press paper* is somewhere between rough and smooth. Unlike rough, it has been weighted down in the drying process, but without heat added—literally, cold-pressed. Its surface is just pleasantly textured—the best of both worlds.

With cold-press paper, you can create your own textures or take advantage of the subtle texture of the paper itself for dry-brush effects (see our exercises in chapter two). You can put down a nice graded wash with very little trouble.

Hot-press paper is very smooth—because it has been pressed with a hot iron. With this surface, you create your *own* textures, since the paper has virtually none of its own. It also makes nice *puddles*, or hard-edged shapes, where pools of pigment have dried. These can be very exciting if you are expecting them and plan for them. If you prefer a smoothly blended, wet-in-wet, "misty" effect or

TIP

You might want to buy a paper sampler and explore your options even if you're not a beginner. (We all need to take a fresh look at what we're doing and what's available on the market now and again.)

Try out rough and cold-press, heavy and light papers. Experiment with the super-absorbent Oriental papers if you like, just to see how they act. Look at this as play—*as exploring new territory. You don't have to master them all—just find the one you like best.*

more control, use cold-press paper.

Watercolor paper comes in various weights, from 70 lb. to 140 lb. to 300 lb. and more. This refers to the weight of 144 sheets, not to a single sheet. A sheet of 300-lb. paper is much thicker than the same-sized sheet of 70-lb. The heavy-weight stuff doesn't need stretching or taping down when painting to keep it from buckling, no matter how wet you paint.

One hundred forty-pound paper has a nice medium weight and generally doesn't need stretching either—the ripples that may occur in this paper during painting will generally disappear when it dries. Seventy-pound paper, on the other hand, buckles badly when wet. It *is* the least expensive, though, so if you prefer, try it out on very *small* paintings or stretch it before painting for best results. (We'll get to the how-to of stretching a bit further on.)

The designations for the "heavier" weights (555-lb., 1,114-lb.) that you may see refer generally to the fact that those types of papers are larger than 22″ × 30″, not *thicker* than the 300-lb. designation. Generally speaking, the heavier the paper, the more expensive it is.

Test each of these papers with some of the basic techniques handled in chapter two to see which you prefer. You may find that you choose one paper for a specific mood or effect and another for a different purpose.

Sizing affects how your chosen paper takes washes and handles abuse. Without sizing, it would be as absorbent as a paper towel. Smooth washes or crisp edges would be impossible. Sizing also adds strength, allowing you to "get rough" for certain effects without ripping through the paper. On a paper with *lots* of sizing, like Arches, you can scrape, sponge and even sand the surface.

Stretching Watercolor Paper—or Not

It usually isn't necessary to stretch your paper, even if you're using 140-lb. instead of the heavier stuff. (Although I'd certainly recommend stretching the 70-lb. papers.) Instead, just tape your paper to your board with 1½"-wide masking or drafting tape. What small rippling does occur in the painting process dries flat.

If you *do* want to stretch—and I'll admit, the taut surface that resists buckling even under the wettest washes is nice—here's how to go about it:

1. Get a sheet of plywood or Masonite (marine finish but not oil-

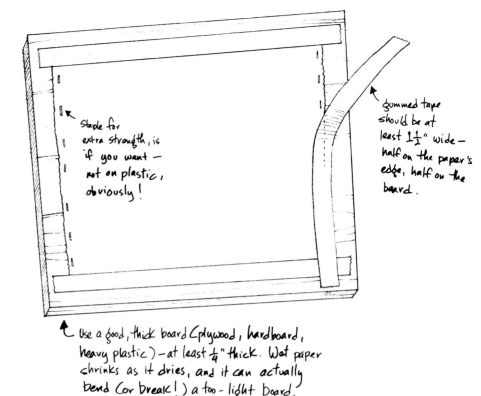

Staple for extra strength, is if you want — not on plastic, obviously!

gummed tape should be at least 1½" wide — half on the paper's edge, half on the board.

Use a good, thick board (plywood, hardboard, heavy plastic) — at least ¼" thick. Wet paper shrinks as it dries, and it can actually bend (or break!) a too-light board.

coated) a few inches larger than the size of your paper. Wet down your paper well on both sides. (Spray it with the dish sprayer on the sink, take it into the shower, or soak it in the tub until it's really wet through.)

2. Lay your paper on your painting surface, and using wide (at least 1½") gummed tape—the type that must be moistened—fasten it down well on all four edges. Make sure that at least half the width of the tape is on the paper.

3. Some artists staple the edge of the paper to the board at close intervals before taping, to ensure success—easier to do in plywood than fiberboard. (You can also buy a stretching board that is said to work quite well.)

4. Let it dry naturally—don't try to hurry it along with a hair dryer or other artificial heat source, which can produce an uneven pull. If possible, let it dry flat, for the same reason, rather than propping the support up against the wall. (Gravity pulls the moisture to the bottom, and the top dries first.)

TIP

The tape provides a clean, white edge. If you want, you can remove it in the middle of a painting—the edge acts as a trial mat and allows you to evaluate your progress. Replace the tape if you feel you're not finished. Make sure your painting is completely dry before removing the tape, though—when the paper is damp, it is liable to tear.

TIP

If you find that you really prefer a firm, wrinkle-free surface but don't like to stretch paper, you can buy watercolor board; Strathmore's Crescent Board is very good. It is expensive, but you can cut the large sheets to any size you like. (Since it has been bonded to a cardboard backing, the rough surface is a bit smoother than unbonded paper.)

Brushing Up

Once upon a time, watercolorists bought several sizes of round red sable brushes and let it go at that. Now we can't get by without a choice of flats, rounds, chisels, fans, bristle brushes, what have you.

Quality *is* important—but there are degrees of quality and reasons for choosing them.

Kolinsky is the best brush hair available, made from the tails of a rare Siberian marten. Soft, springy, thick, Kolinsky makes a wonderful point and holds a lot of water; it's simply the best. Red sable, slightly less expensive, is from the tail of the Asiatic weasel; it, too, is a pleasure to use.

Camel-hair brushes, oddly enough, may not contain any more of a camel than its name; that's a trade name for brushes containing squirrel, pony, bear or goat hair, or any combination thereof. A less expensive brush—one, say, with man-made fibers mixed in with natural animal hairs like the Sceptre brand—handles differently from sable, but it is still a viable option.

Some perfectly usable brushes are *completely* man-made, and are much less expensive than Kolinsky or red sable. They may not hold quite as much liquid as the natural-hair brushes, but they have a nice snap, and they hold a point well.

Round watercolor brushes come in sizes from 000 to 24; I like to keep a no. 5, a no. 8 and a no. 12 handy, and I find that if they maintain a good point, the fives are plenty small enough for details. Sable rounds are prized for their ability to point well and still deliver a load of pigment; the use of sable for other brush types is far less critical. A mixture of natural hair and man-made fibers or a completely manufactured "hair" may be just fine for other brushes.

Flat brushes—sable or otherwise—are often sold by width: half-inch, inch, etc., but they may also be sold by a size number. Try to have a ½-inch, a ¾-inch and a 1-inch on hand. Flats may have longer or shorter hairs proportionately to their width; the shorter brushes are easier to handle but don't hold as much water. I usually prefer them, though, because the longer ones may spring back when you lift them off the page, spattering your work with droplets of color. Look for a brush that's not much longer than it is wide. Many flat brushes come with an angled end (right) on the plastic handle that is excellent for scraping and lifting.

Good brands are Winsor & Newton, Grumbacher, Raphael, Robert

TIP

Test before you buy, if possible; most good art supply stores offer containers of clear water. Rinse the brush to rid it of sizing (yes, brushes are sized, too, for protection during shipping), make a snapping motion with your wrist to flip the excess water out, and look to see if the brush has maintained a good point; if it has, buy it.

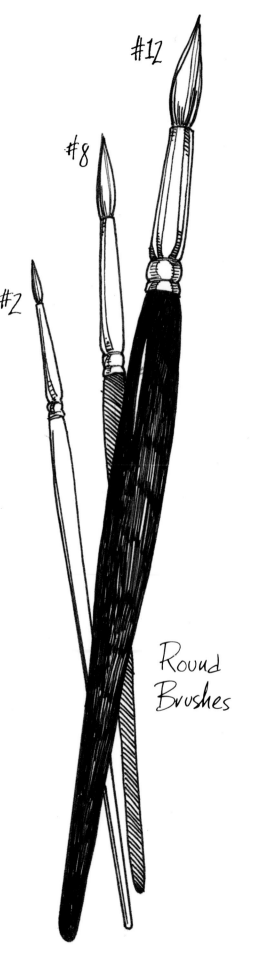

#12

#8

#2

Round Brushes

Simmons, Masterstroke, Loew-Cornell, Daniel Smith, Isabey, Liquitex, Artsign, White Sable and Golden Taklon. My favorite man-made brushes are Loew-Cornell's "La Corneille," which keep their point for a long time and cost very little.

Beyond Basic Brushes

Beginners often try to get by with tiny little brushes—don't. It just makes it harder to learn to handle the medium. Tiny, tiny brushes don't hold enough liquid and encourage overly tight handling. If price is a factor, try the man-made brushes, but get at least a no. 8 or no. 10 round and a ½-inch and a 1-inch flat. You'll want to choose the largest brush you can comfortably work with to paint. It will hold more water and pigment—and cover more ground before needing refilling with fresh paint.

Take care of your brushes; don't stand them on their tips in water or they'll set up that way. Don't soak them overnight, either; that can soften the glue that holds the hairs in place. A canvas or reed brush holder will protect their tips during travel. At home, you may want to store brushes upright in a jar on their handles, or in a drawer with a few mothballs if you can't paint for long periods. (Moths and other critters like fine watercolor brushes as much as they do woolens.)

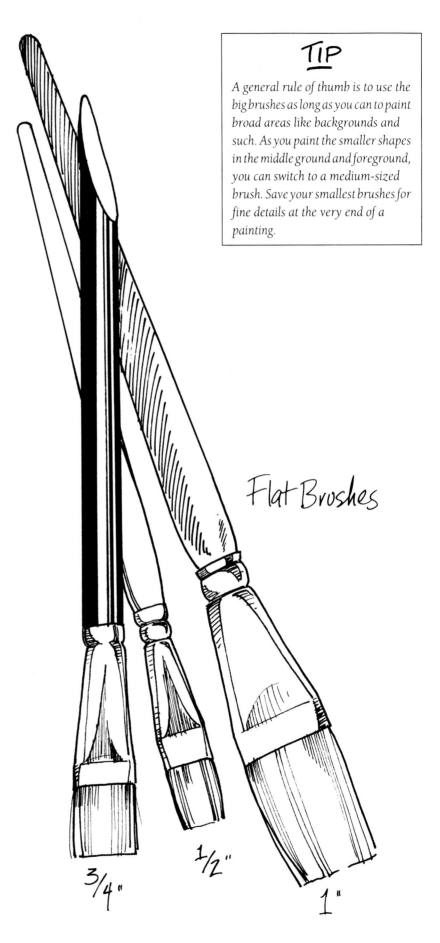

Flat Brushes

3/4"

1/2"

1"

TIP

A general rule of thumb is to use the big brushes as long as you can to paint broad areas like backgrounds and such. As you paint the smaller shapes in the middle ground and foreground, you can switch to a medium-sized brush. Save your smallest brushes for fine details at the very end of a painting.

TIP

Flats and rounds alone will get you by for the basic techniques—two or three of each in various sizes would be sufficient.

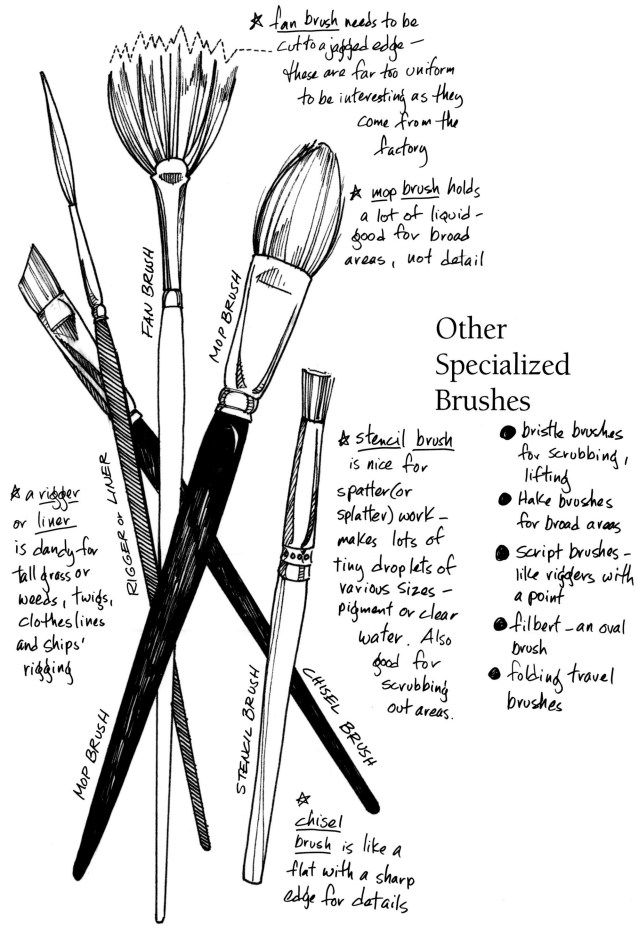

☆ fan brush needs to be cut to a jagged edge — these are far too uniform to be interesting as they come from the factory

☆ mop brush holds a lot of liquid — good for broad areas, not detail

Other Specialized Brushes

FAN BRUSH

MOP BRUSH

RIGGER or LINER

MOP BRUSH

STENCIL BRUSH

CHISEL BRUSH

☆ a rigger or liner is dandy for tall grass or weeds, twigs, clotheslines and ships' rigging

☆ stencil brush is nice for spatter (or splatter) work — makes lots of tiny droplets of various sizes — pigment or clear water. Also good for scrubbing out areas.

● bristle brushes for scrubbing, lifting
● Hake brushes for broad areas
● Script brushes — like riggers with a point
● filbert — an oval brush
● folding travel brushes

☆ chisel brush is like a flat with a sharp edge for details

A Rainbow of Paints

For ease of handling and permanence, choose *artist's grade* rather than student grade. My feeling has always been that when you're getting started in *any* medium, it's best not to waste time fighting less-than-professional-grade supplies. I'd choose a limited palette of only a few colors and go with the best. But if you are *really* just getting started and want to explore the medium for as small a cash outlay as possible, try a small set of student grade paints for a while. A *short* while.

If you want to try a limited palette, buy a warm and a cool shade of yellow and of blue—plus a couple of earth colors.

Alizarin Crimson (cool)
Cadmium Red Medium (warm)

Thalo or Antwerp Blue (cool)
Ultramarine (warm)

Cadmium Yellow Lemon (cool)
Cadmium Yellow Medium (warm)

Also get Burnt and Raw Umber and Burnt and Raw Sienna. With just these colors, you can mix all your secondary greens, purples and oranges, just like we learned in school.

I sometimes supplement this list with a Hooker's Green Dark and a Winsor Green for fast mixing. I use Permanent Rose when I'm doing spring flowers or need a clean, clear lavender—Alizarin Crimson just doesn't get it.

An even more limited palette could contain a *single* red, blue and yellow, plus an earth color or two—you sacrifice some purity in the secondaries, but it's a good place to start if price is a serious consideration.

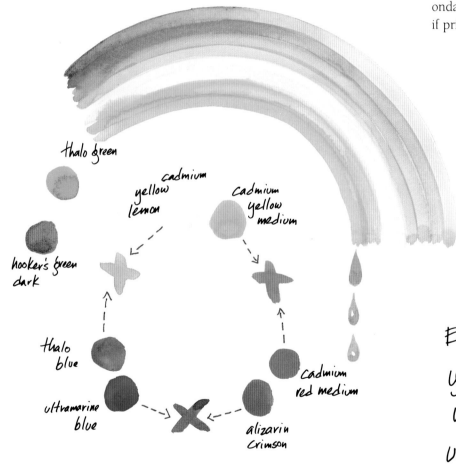

thalo green

cadmium yellow lemon

cadmium yellow medium

hooker's green dark

thalo blue

ultramarine blue

cadmium red medium

alizarin crimson

Even a few paints on your palette will make an unlimited rainbow of colors.

burnt umber

burnt sienna

raw sienna

13

The Artist's Palette

Here, we're not discussing the pigments you choose but the surface you mix them on—also called a *palette*. Your palette should have an edge of at least a quarter of an inch to keep washes from spilling, and it should be white, to allow you to judge the color and strength of your paint mixtures. A butcher's enamel tray is relatively inexpensive. A high-impact plastic or plastic-and-rubber mix is fine, too, and available almost anywhere art supplies are sold. A white porcelain dinner plate or platter works well, but a palette with dividers around the edge for mounds of paint keeps colors from running together.

I use a John Pike palette, which has a lid to protect my paints from dust (and cat hair!). The lid acts as an additional mixing space for big washes. The San Francisco Slant palette is nice for the variety of mixing wells to keep your washes pure and separate, or you may find that you prefer a smaller, round palette arranged like a color wheel to organize your paints for quick mixing.

How Much Will This Cost?

How much you spend depends on what you've decided is basic. You can get started for about twenty-five to fifty dollars if you're careful. A quick look at one of the catalogs (not a discount one, either) turned up a good-sized plastic palette for about twelve dollars; a basic set of twelve small tubes of color for just over seven dollars; two man-made brushes (a 1-inch flat and a no. 8 round) for about fifteen dollars; and a 10″ × 14″ block of fifteen sheets of watercolor paper for about twelve dollars (a 15″ × 20″ block was about twenty). Ten sheets of 22″ × 30″ rough watercolor paper, 140-lb., cost just over three dollars a sheet, not such a bad investment in

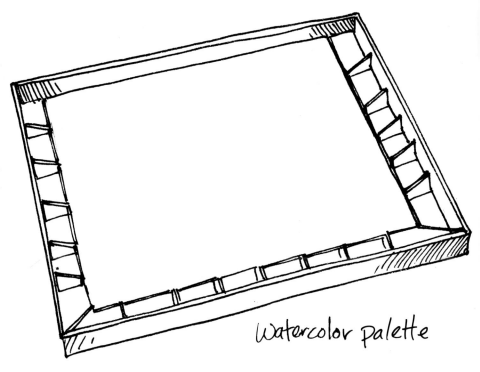

watercolor palette

yourself—especially if you cut them to size to make them go farther.

Some Further "Necessities"

▶ Unless you're using a watercolor block or a good, thick pad, you'll need a *painting surface* to support your paper. Quarter-inch marine plywood is good; varnish it to make it impervious to water, if you like. Hardboard is another fine choice; be careful to avoid the oil-finished product. At your art supply store, you can get hardboard painting supports with a handle cut out and big metal clips at one end to hold several sheets of paper.

I often use a sheet of Plexiglas, which has a nonporous surface that helps hold the moisture in the paper longer.

▶ *Drafting* or *masking tape* is fine to attach paper to the board (remove it carefully when the painting is bone dry) or use *staples* or *bulldog clips*, which can be moved during painting, if you like.

> ### TIP
> *Pull tape off at an acute angle to your paper to minimize damage or tearing.*

> ### TIP
> *If you use a brush to apply your mask, dampen it with soapy water first so you can easily wash out the rubbery liquid when you're done.*

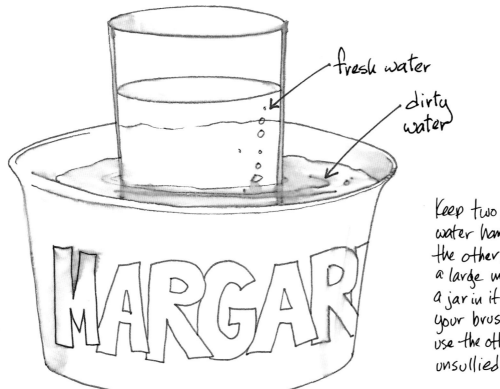

fresh water

dirty water

Keep two containers of water handy, one within the other, if you like—try a large margarine tub with a jar in it. You can rinse your brush in one and use the other for mixing unsullied washes.

▶ *Liquid rubber masks* are helpful for protecting whites when you splash on preliminary washes; Maskoid, Miskit, Liquid Frisket and Incredible White Mask are some familiar brand names.

▶ You'll need a *pencil* and an *eraser*; not too many people paint directly with no guidelines. A no. 2 or HB pencil is basic, but choose the finest, gentlest eraser you can find. A White Magic works well, as does Pentel's Clic Eraser. Neither will damage the surface of your watercolor paper.

▶ Your *water container* should be unbreakable. For travel, I use an old army canteen with a cup.

▶ Use *sponges* to wet paper with clear water, remove excess sizing, mop up, lift color or to paint with.

Pick up a selection of natural and man-made ones.

▶ Keep *paper towels or tissues* handy. A paper towel in one hand and a brush in the other allows you to quickly change the texture of a wash, lighten an area, or pick up a bobble or spill so it doesn't even show—if you're prepared.

▶ A *portable hair dryer* set on warm will speed drying, but keep it moving at a distance of perhaps 18″ from your paper or you may make hard edges.

▶ That *spray bottle* can be quite handy for more than moistening dried paint. If an area of your painting has gotten too busy, spray it and flood in a unifying wash. Soften edges of a wash with a shot of spray, too.

Earth Colors

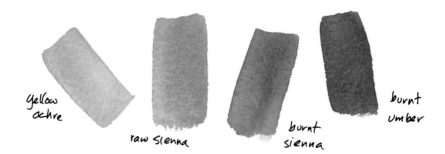

yellow
ochre

raw sienna

burnt
sienna

burnt
umber

EARTH COLORS ARE VERY HANDY....

(you can mix them with cool and warm blues to make a
variety of greens and grays)

BUT THEY ARE EXPENDABLE !

Here, we've mixed a nice variety of browns and grays
using just the primaries.

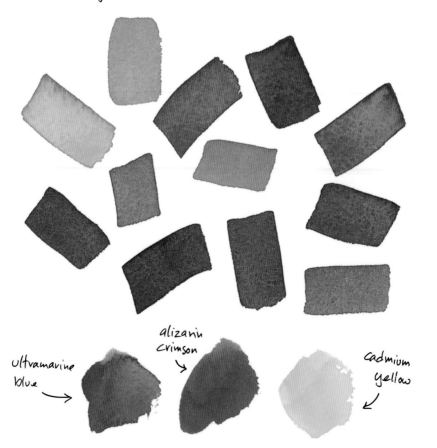

alizarin
Crimson

ultramarine
blue →

Cadmium
yellow
↙

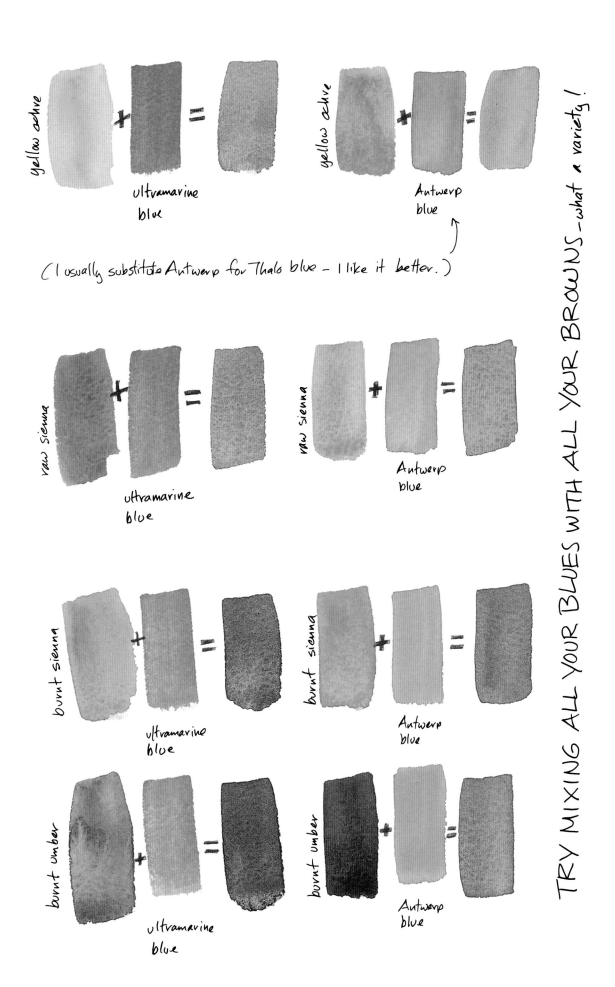

yellow ochre + ultramarine blue =

yellow ochre + Antwerp blue =

(I usually substitute Antwerp for Thalo blue — I like it better.)

raw sienna + ultramarine blue =

raw sienna + Antwerp blue =

burnt sienna + ultramarine blue =

burnt sienna + Antwerp blue =

burnt umber + ultramarine blue =

burnt umber + Antwerp blue =

TRY MIXING ALL YOUR BLUES WITH ALL YOUR BROWNS — what a variety!

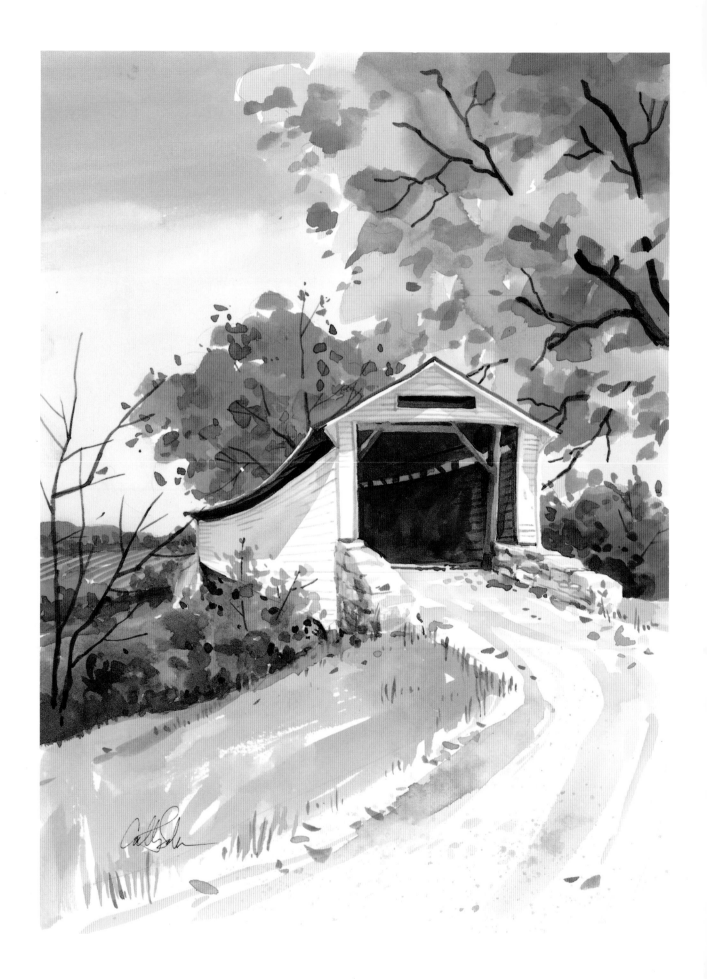

Chapter Two

EASY-TO-LEARN WAYS TO PAINT

Like any new skill, watercolor takes learning the ropes. It's best to start with the basics—simple, classic exercises that allow you the most control (and the least frustration) for your efforts. I don't mean dry and boring stuff here, just learning the ins and outs of how to apply paint to paper. It's like exploring; it's play—and it helps you loosen up and get over the fear of blank white paper.

If you go at watercolor expecting it to handle like oils—or anything other than itself—you'll miss the beauty and spontaneity of the medium. Watercolor is like nothing else: It's transparent, it goes on fast, and individual brushstrokes are extremely expressive. If you work quickly, without belaboring or scrubbing, you can keep it fresh. And expect the unexpected, even with preparation.

These preparations needn't be laborious or time consuming. Planning ahead is just the mental packing you do before the trip, and the few little details you see to make sure your painting turns out well. The hairpin turns you negotiate—and the lovely sights you see—are what makes the ride memorable.

If you've never painted with watercolor before, you may have some questions; we all do. First, relax. This isn't brain surgery, it's fun. All it takes is a bit of practice, and unlike learning to ride a bike, you aren't even going to get a skinned knee if you goof. Try these basic exercises, and before you know it, you'll find your balance and ride off like a pro.

Putting Brush to Paper

Faced with your first watercolor painting, you may need some explanation of simply getting the paint on the paper. If you've squeezed out fresh pigment directly from the tube, your mounds of paint will still be soft and easily mixable. If, on the other hand, you've bought pan watercolors or you've put tube paint on your palette and allowed it to dry, as I do (it's less likely to drip or ooze if I go out-side to paint), you'll need to refresh your colors. Do this by spraying the mounds with fresh, clean water—or by putting a few drops of water on each one with your biggest brush. Allow the paint to absorb the moisture for a minute or two, and it will mix almost as quickly as fresh-squeezed.

Now, swish your brush in your container of clean water, then into the mound of paint. Stir it around a little, and move that brushload to your palette. Keep doing that until you have a big enough pool of paint—you may need to go back to your mound of color several times.

Take a brushload of your mixture and touch it to the paper. Make whatever marks you want—in fact, you may want to try out our next exercises—that way you'll learn what your brushes will do, and at the same time get comfortable with moving paint between your palette and your watercolor paper.

Let the pure colors mix right on your paper, if you like, for exciting effects. Sometimes the variation in tone or hue is really nice.

TIP

If you want to mix more than one color—a yellow and blue for green, for instance—rinse your brush between colors to keep from sullying the mounds of paint on your palette. Then switch colors and take that brushload to the puddle on your mixing surface.

TIP

If you've been painting for awhile and your palette's surface is full of nineteen different colors, you're in danger of getting muddy mixtures (or lovely, subtle "palette grays," depending on your outlook). Spray the mixing area with clean water and pick up the residue with a paper towel. I plan on doing this several times during the course of a painting.

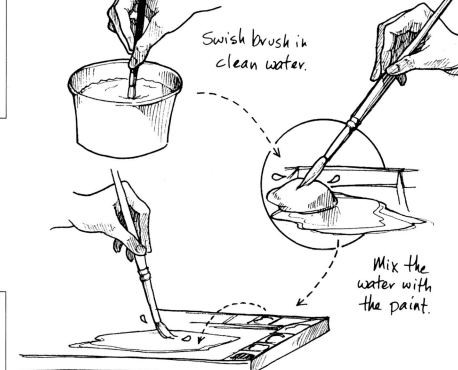

Swish brush in clean water.

Mix the water with the paint.

Transfer a brushload of color to the palette's mixing area. Repeat as often as necessary.

Mixing Up a Batch of Paint

One of the hardest things for the beginner is learning how to mix *enough* paint for a wash. It's better to have too much than too little. If it's necessary to stop painting to mix more, you may get a hard edge if the first part dries before you can get back to it. If you know you need to cover a broad area, make up a healthy puddle of paint—2-3 tablespoons of water (or ¼ cup or more, if you like, in a small container) and however much pigment it takes to achieve the intensity or value you're after. Use a scrap of the same paper you're painting on to test strength and value. For information about mixing *color*, see the color wheel in the preceding chapter.

Let's start by exploring your vari-ous brushes and what kinds of marks they can make. That way, you'll not only become familiar with your versatile watercolor brushes, but you'll also be used to moving paint around. Then we'll move on to other basic exercises.

If you need to, make notes next to these samples when you're done—they'll act as your own visual aids! These are much better learning tools than illustrations in someone else's book—you'll remember what you did and how you did it. You may want to do these practice runs in a permanent, hardbound sketchbook for your explorations. These books also come filled with watercolor paper. Or, punch holes in your samples and keep them in a ring binder. That way you'll have them all together for quick reference.

TIP

To allow yourself plenty of mixing room, it may be best to have no more than two or three large puddles of paint on your mixing surface and maybe two or three more small ones at any given time.

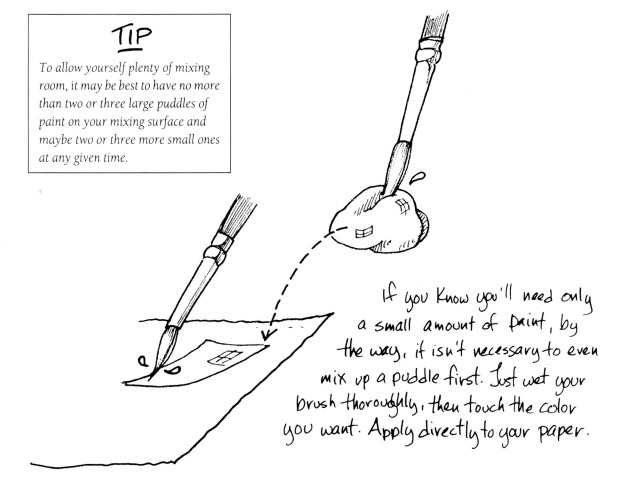

If you know you'll need only a small amount of paint, by the way, it isn't necessary to even mix up a puddle first. Just wet your brush thoroughly, then touch the color you want. Apply directly to your paper.

Round Brush Exercises

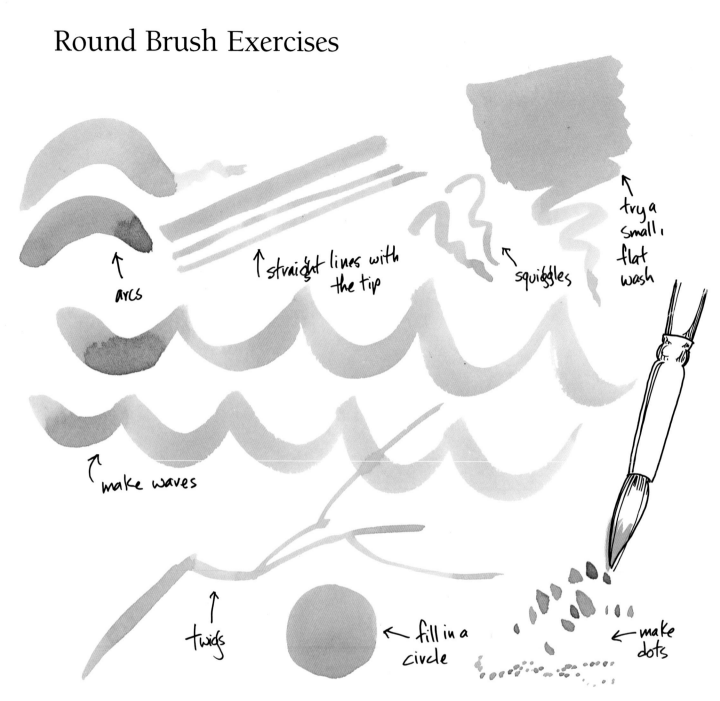

arcs

straight lines with the tip

squiggles

try a small, flat wash

make waves

twigs

fill in a circle

make dots

Get out your biggest <u>round brush</u> and make a big puddle of color on your palette — you'll need a fair amount to try out this brush to the fullest. Fill the brush with a good, wet load.

Press the brush firmly onto the paper, holding it upright, or just skim over the surface with the handle close to the paper. (The angle at which you hold a brush makes a big difference in the marks it makes.) Whatever you can think of to do, <u>do</u> it.

Flat Brush Exercises

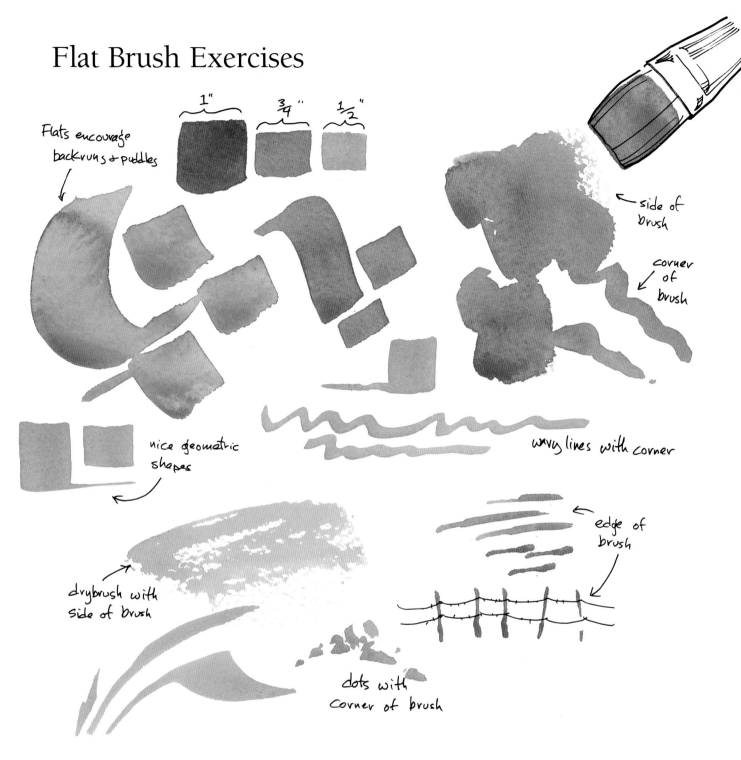

1" 3/4" 1/2"

Flats encourage backruns & puddles

side of brush

corner of brush

nice geometric shapes

wavy lines with corner

drybrush with side of brush

edge of brush

dots with corner of brush

Now try out your _flat brush_ the same way. By its very shape it does well with geometric forms —but experiment to see what else it can do. It's amazingly versatile.

Rigger Brush Exercises

☆ See what Kinds of marks your <u>rigger</u> can make — it's not just for lines, you Know. Wiggle it, spread the hairs, make dots — whatever. It makes a nice, dancing line for twigs, too.

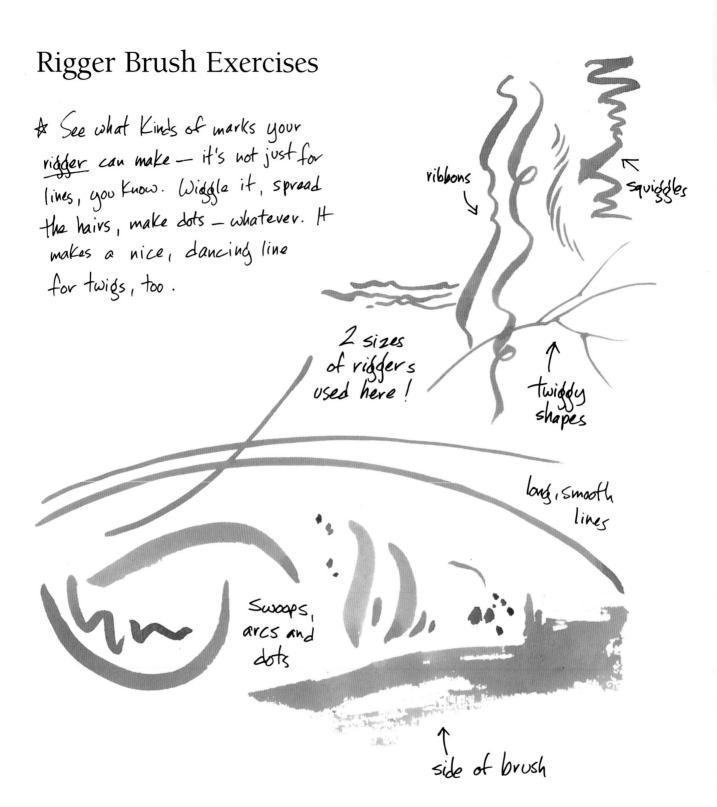

ribbons

squiggles

2 sizes of riggers used here!

twiggy shapes

long, smooth lines

Swoops, arcs and dots

side of brush

See what Kinds of marks your <u>rigger</u> can make — it's not just for lines, you Know. Wiggle it, spread the hairs, make dots — whatever. It makes a nice, dancing line for twigs, too.

Fan Brush Exercises

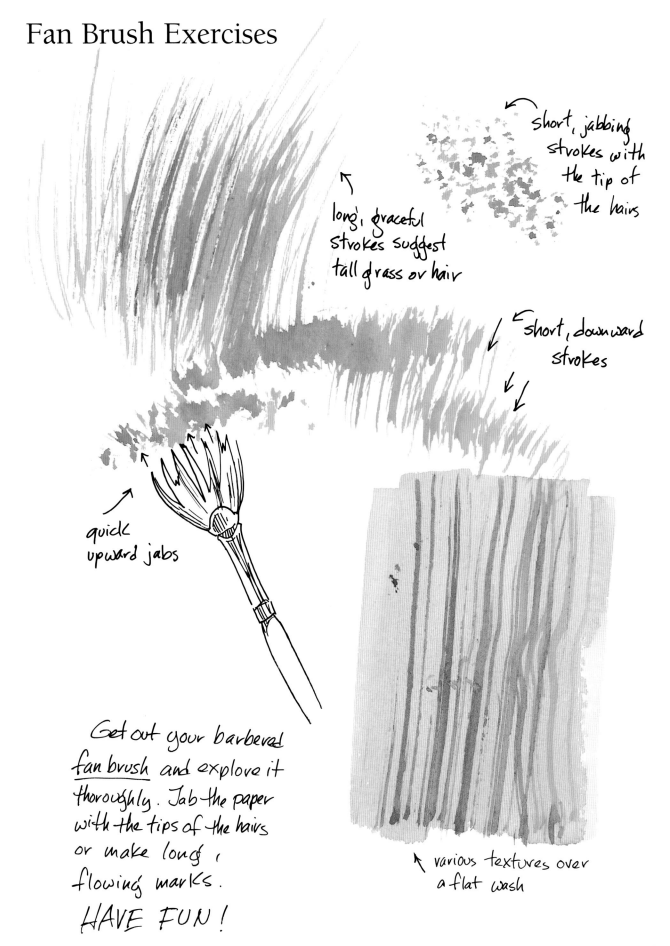

short, jabbing strokes with the tip of the hairs

long, graceful strokes suggest tall grass or hair

short, downward strokes

quick upward jabs

Get out your barbered fan brush and explore it thoroughly. Jab the paper with the tips of the hairs or make long, flowing marks. HAVE FUN !

various textures over a flat wash

Stencil Brush Exercises

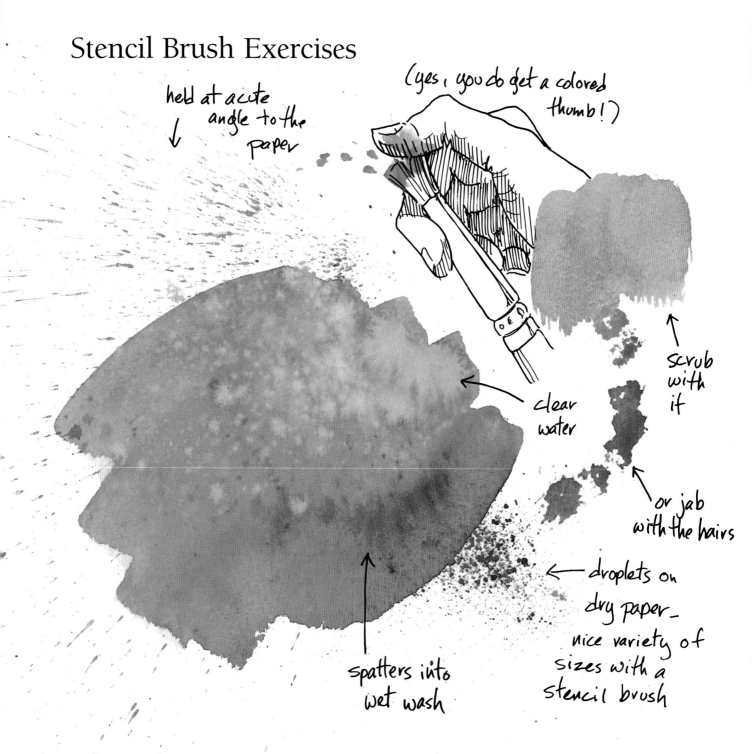

held at acute angle to the paper

(yes, you do get a colored thumb!)

scrub with it

clear water

or jab with the hairs

droplets on dry paper—nice variety of sizes with a stencil brush

spatters into wet wash

Try out your <u>stencil brush</u> for spattering. Touch it to a pool of paint and then rub your thumb over the edge—aim it directly at your paper or at an acute angle. Blot some of your dots with a tissue. Try painting with this brush, too—you won't have a lot of control for details, but it makes nice, loose, rough-edged shapes.

Other Brushes

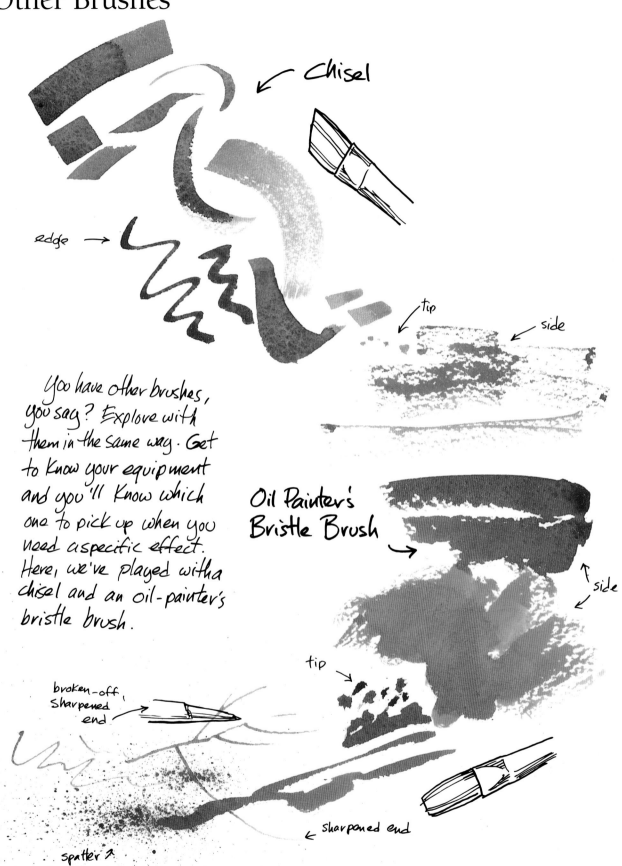

Chisel

edge →

You have other brushes, you say? Explore with them in the same way. Get to know your equipment and you'll know which one to pick up when you need a specific effect. Here, we've played with a chisel and an oil-painter's bristle brush.

tip

side

Oil Painter's Bristle Brush

side

tip

broken-off, sharpened end

← sharpened end

spatter ↗

Assorted Tools

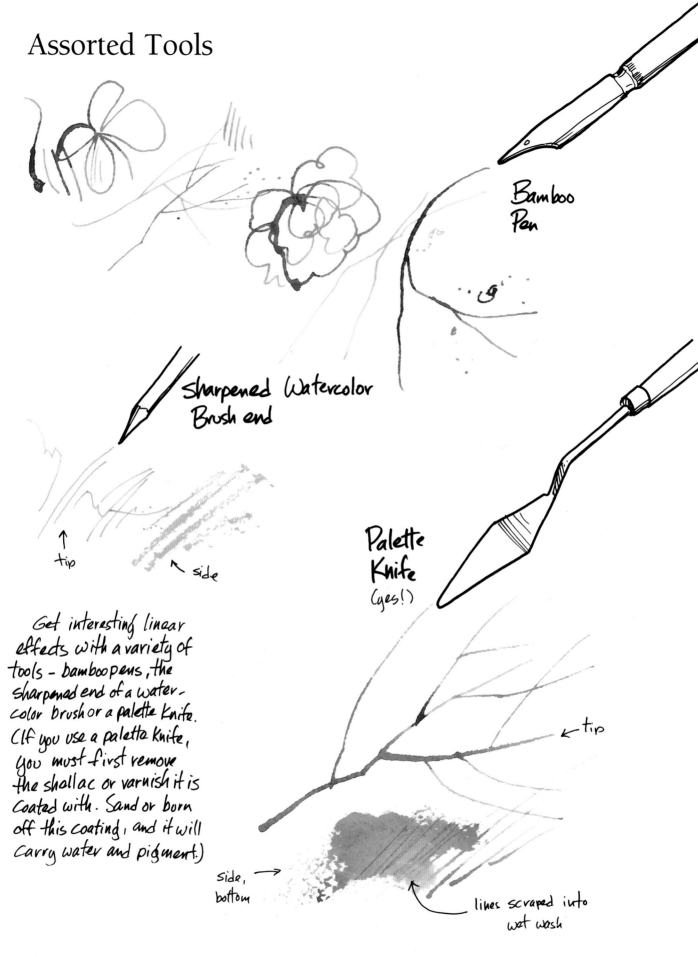

Bamboo
Pen

Sharpened Watercolor
Brush end

↑
tip ← side

Get interesting linear
effects with a variety of
tools - bamboo pens, the
sharpened end of a water-
color brush or a palette knife.
(If you use a palette knife,
you must first remove
the shellac or varnish it is
coated with. Sand or burn
off this coating, and it will
carry water and pigment.)

Palette
Knife
(yes!)

← tip

side, →
bottom

lines scraped into
wet wash

Assorted Tools

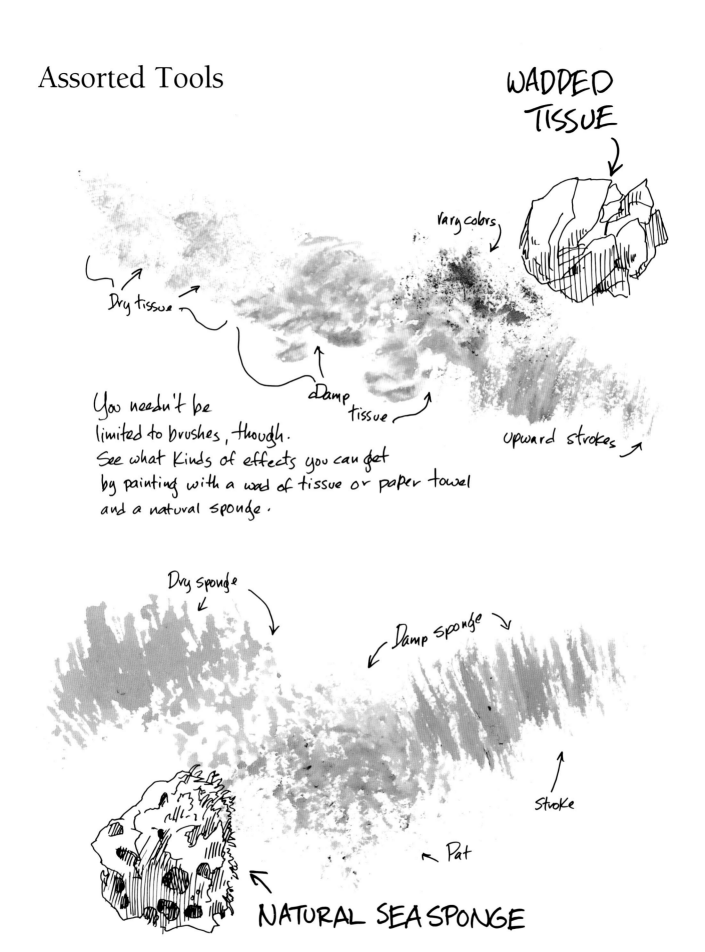

WADDED
TISSUE

varg colors

Dry tissue

Damp
tissue

upward strokes

You needn't be
limited to brushes, though.
See what kinds of effects you can get
by painting with a wad of tissue or paper towel
and a natural sponge.

Dry sponge

Damp sponge

Stroke

Pat

NATURAL SEA SPONGE

Sprayers

this is what
happened when I
tried to hurry
drying with a
portable hair
dryer

wash on
dry paper

Clear water
with color
flooded in

hit edge
with a
spray of
water— it
becomes
broken and
lacy

✳ Sprayers are
delightfully versatile,
as well. They're
inexpensive, easy to
find, and create a
variety of special
effects. Spray before
or after painting.

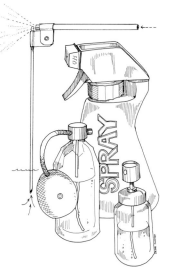

Fear-Conquering Exercises

Everybody has a moment of anxiety when faced with that white sheet of paper—beginners have no corner on that! I've been painting twenty years, and that's still the case for me. The image in my mind never matches reality—but sometimes it's *better* than I imagined, and it's always a challenge and a pleasure. The **"happy accidents"** of watercolor are what make it such an exciting medium. Remember, don't take it seriously. Painting is a great joy—again, it isn't brain surgery or rock climbing. You're not going to get hurt, and neither is anyone else. Here are a couple of exercises to get you past that butterflies-in-the-stomach stage.

 Watercolor Dictionary: Happy accident

This *can* look like a disaster, but on reflection, you may like the way it looks. It's not a calamity, even though you didn't plan it. *Happy accident* can also refer to any of the mishaps that result in an effect you really like—but would never have tried up front—like having the cat suddenly run across your paper, dripping pigment into a damp wash, or dropping your painting on its face at a crucial moment. (You can create your own happy accidents, once you learn what the end result will be, and everyone will wonder how you got that great effect.)

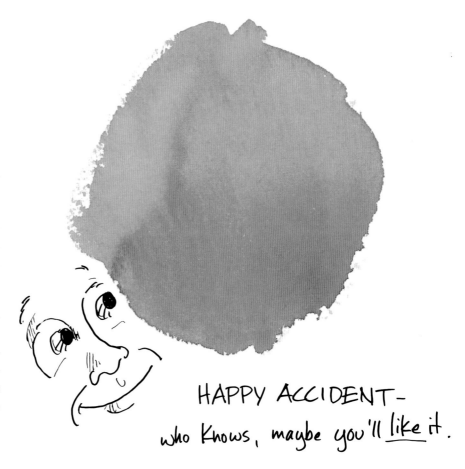

HAPPY ACCIDENT— who knows, maybe you'll <u>like</u> it.

TIP

Have you noticed your paint water getting pretty muddy by now? Dump it out and get fresh: Clean water for mixing washes and for washing out your brush keeps the color sparkling. Water is the least expensive thing we use when painting.

To ensure clean mixtures, many artists use one water container for washing brushes and another for mixing washes.

TIP

If fear of wasting paper is a problem, start out with the less expensive stuff—but don't use the really nasty student-grade pads with boring, mechanical surfaces, because you'll end up hating the medium. Consider Fabriano Classico or Morilla. Both of these have interesting textures and nice surfaces for practice work—and after.

Fear-Conquering Exercise #1

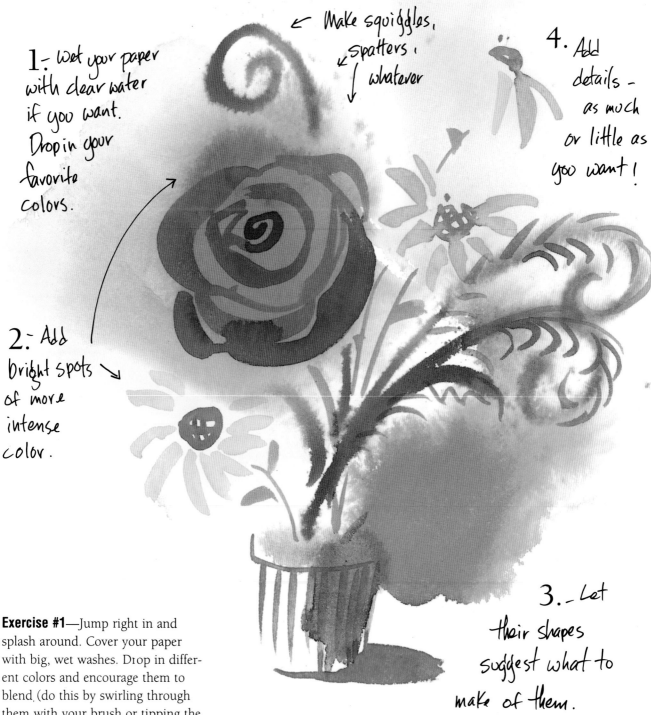

1. Wet your paper with clear water if you want. Drop in your favorite colors.

← Make squiggles, spatters, whatever

4. Add details - as much or little as you want!

2. Add bright spots of more intense color.

3. Let their shapes suggest what to make of them.

Exercise #1—Jump right in and splash around. Cover your paper with big, wet washes. Drop in different colors and encourage them to blend (do this by swirling through them with your brush or tipping the paper). Let bright drips of color fall on the paper, or spatter with your stencil brush. Now, let it all dry and see what the shapes suggest to you. See if you can define them into some form, or add **calligraphic** little brushstrokes to draw a shape. Add small washes to "found" details.

Watercolor Dictionary: Calligraphic

This simply means using your brush as you might a fine lettering or drawing pen. It results in a linear effect, with wonderful thick-and-thin lines.

32

Fear Conquering Exercise #2

1. - Make an irregular shape — any shape or color & let it dry thoroughly.

2. - Look at it until you see something there

3. - Now - make what you saw in your mind's eye appear on paper !

Go wild — add all the details you want !

Use your pencil first, if you like

(I feel as though I just conquered a dragon)

HAVE FUN !

Exercise #2—Make a shape on your paper—any shape at all. It's OK for the background to be white. Let your shape dry, and again, see what it suggests. Turn it upside down or on its ear if you want. See if you can turn your odd shape into a dragon, a flower, a barn.

Basic Techniques

These simple techniques are the basics you'll be using over and over. Try them out one at a time until you feel comfortable with them—they're quick and easy, especially in small doses. Do a flat wash, a graded wash, a variegated wash, a puddle, or a bit of dry-brush work. Don't expect them to look like anything at the moment—and don't demand perfection of yourself; just play with them. Now put them together—two or three at a time—please, not all at once! In combination, these basic techniques will see you through most painting situations; they've been used for centuries. With a little practice, you'll handle them with ease.

These basic techniques are the A,B,C's of watercolor painting.

Flat Washes and...

Graded Wash and...

Glazes....

AB G etc.

Flat Washes

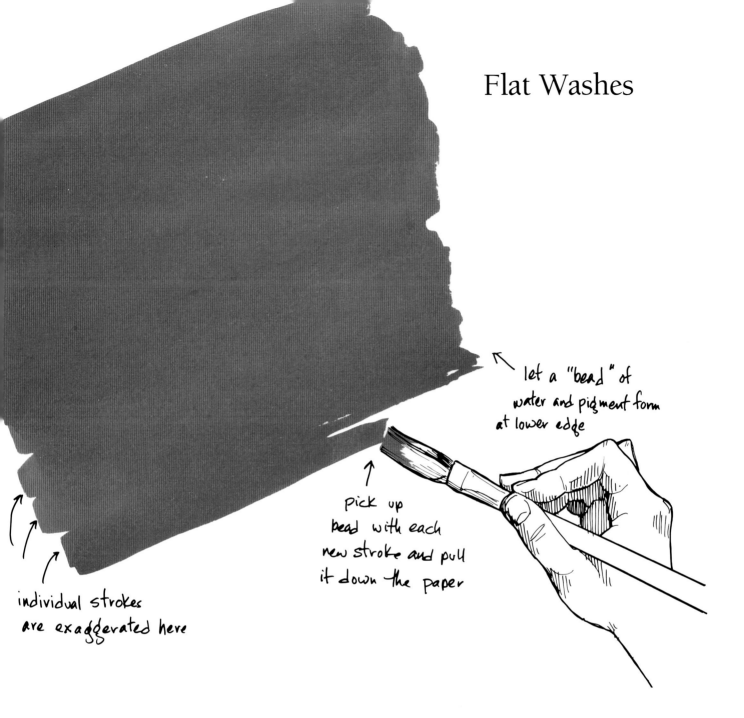

let a "bead" of water and pigment form at lower edge

pick up bead with each new stroke and pull it down the paper

individual strokes are exaggerated here

Flat washes: These are smooth washes with an unbroken tone. They are sometimes used for buildings, but in representational painting, they're less useful than in abstract or decorative works. (There's just not that much that's flat in nature.)

How to: Mix up a good-sized pool of water and pigment, and make a line of color at the top of your paper. Keep your support at a slight angle to encourage the paint to flow downwards, forming a puddle or "bead" at the lower edge. With your next brush-load of paint, pick up that bead and draw it down the page. Continue until you fill the desired area, then lift the final bead of paint with a wrung-out, "thirsty" brush or the corner of a paper towel; otherwise, it will make a **backrun** or **flower** as it dries.

Watercolor Dictionary: Backruns, Flowers

Backruns or flowers are odd-shaped, hard edges that form when you let a wet wash dry without picking up the pool of paint that sometimes collects on the finishing edge. If you want your flat wash to remain flat, mop it up with a corner of a paper towel or a damp brush. (Just touch it, don't blot it—let the moisture move up the towel or brush naturally.)

Graded Wash

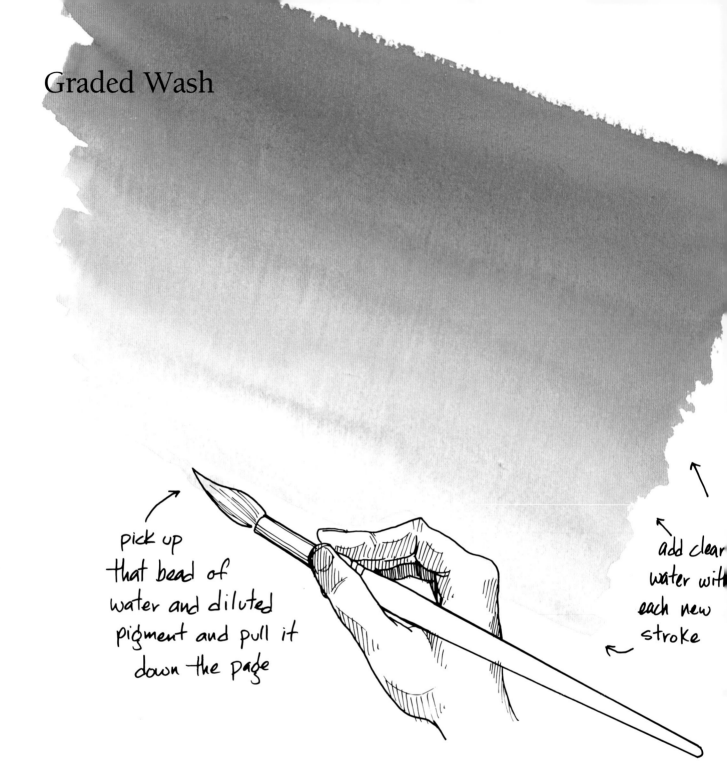

pick up that bead of water and diluted pigment and pull it down the page

add clear water with each new stroke

Graded washes: There's no "pass" or "fail" grade on this wash. It simply means the tone is graduated from darker to lighter or the other way around. (Washes can also be graded from color to color—for example, from blue to yellow.)

How to: Begin this the same as you do a flat wash, but with each brushload of color, add a bit more clear water. Continue down the page until you have almost pure water in your brush, then lift the puddle as before.

If you like, you can begin from clear water at the top and add more and more pigment, finishing up with strong color. For advanced exercises, try adding a different color as you go instead of clear water, so your wash grades from, say, Ultramarine Blue to Alizarin Crimson.

Variegated Wash

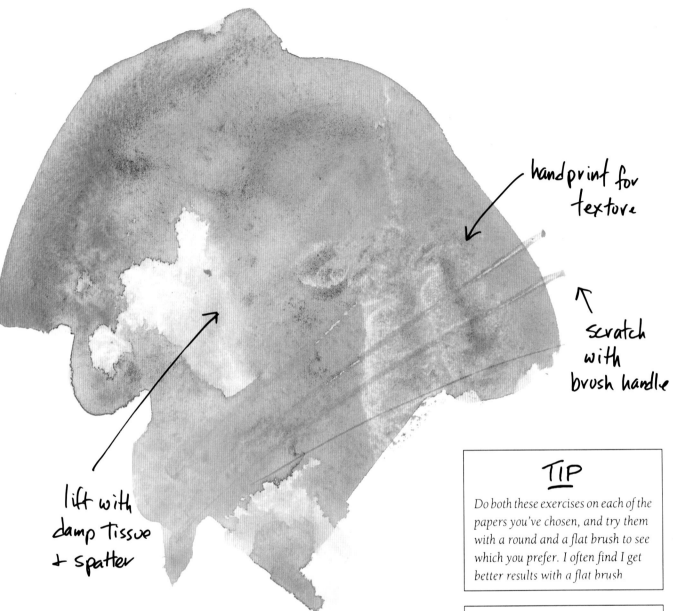

handprint for texture

scratch with brush handle

lift with damp Tissue + spatter

TIP

Do both these exercises on each of the papers you've chosen, and try them with a round and a flat brush to see which you prefer. I often find I get better results with a flat brush

TIP

You may also want to try them on both dry and somewhat wet paper. Some people have better luck with a graded wash on paper that has been wet and has begun to lose its shine somewhat. (Be aware that the paint won't bead along the bottom edge of the wash in the same way it did on dry paper. It's a different way of handling a wash; try it and see which technique you prefer.)

Variegated Wash: This uneven, mottled or textured wash is one that doesn't appear in most watercolor books, but it's one of the most useful. (Who says a wash should be either flat or graded? I like them to have some personality, an uneven light-and-shade pattern, or colors that blend on the page in exciting ways.)

How to: Flood different colors in, splash bits of paint into a damp wash, or touch your wash with a paper towel while it's still wet, for texture. Scratch it with the end of your brush. Variegated washes are useful in a million situations, and they're *easy*, to boot.

Puddles

Puddle: This is a smallish (say no larger than 3″ × 5″), very wet wash that's allowed to dry undisturbed. (You may actually be able to see a slight mound of water and pigment on the paper's surface.) Puddles often dry with a nice, hard edge that's useful in certain situations—fun for balloons, flower petals, small faces or heads, and so forth.

How to: Paint a small wash (or several of them) with a very full brush. Don't try to pick up excess moisture, and don't speed drying with a hair dryer; just let it dry in place, then make it into whatever you want.

TIP

Did you notice? You've already done something similar to these techniques with the "Fear Conquering Exercises." These are sometimes thought of as the most challenging watercolor techniques, and you've already got them nailed!

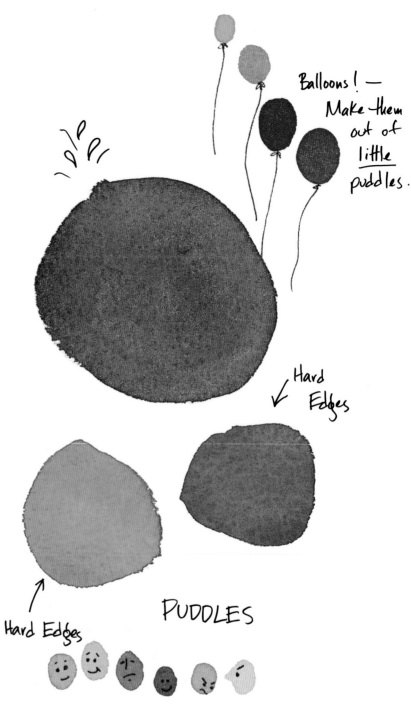

Balloons! — Make them out of *little* puddles.

Hard Edges

Hard Edges

PUDDLES

Use puddles for crowd scenes - vary shapes, value and angle for interest.

Wet-in-Wet

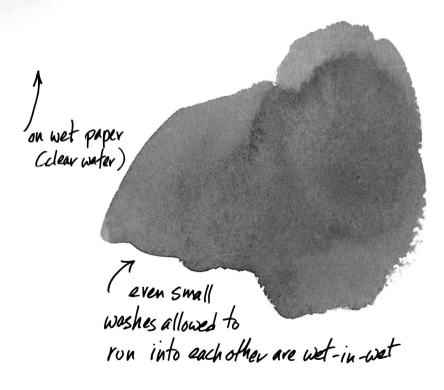

Wet-in-Wet: This is a very splashy technique (if you'll pardon the pun), one often associated with watercolor. Here, you wet down your paper, flood colors into it, then tilt your paper or drop in large areas of color.

How to: Wet your paper down well before painting; some people soak it in the tub. Make a big, juicy wash on your painting surface, and flood in another color or two. Tip your paper, if you like, to see how the paint flows. You can keep working into this until it begins to dry, but be careful: It's a short step between softly flowing colors and hard edges.

It isn't necessary to pre-wet the whole sheet; allowing one fresh wash—however small—to flow into another is still wet-in-wet painting.

on wet paper
(clear water)

even small
washes allowed to
run into each other are wet-in-wet

Drybrush

Drybrush: This is a bit of a misnomer; your brush is not *completely* dry, obviously, or it wouldn't make a mark; you just work with a light touch and less water in your mixture.

How to: There are several ways of working drybrush. One is to load your brush with water and pigment, then touch the tip to a sponge or wad of paper towels to remove most of the moisture. Your brush is fairly full of damp pigment, and you don't have to reload it too quickly.

Or, keep the load rather dry in the first place (don't mix in too much water), then touch just the surface texture of your paper, perhaps with the side of the brush rather than the tip. Here, you have to reload your brush fairly often.

Neither of these requires a tiny brush, by the way—it's more a way of handling your tools.

← over a wash

crosshatched

tiny dots or strokes with the tip of a "wrung-out" brush

The side of a fully loaded brush dragged across the paper at an acute angle

← light on water?

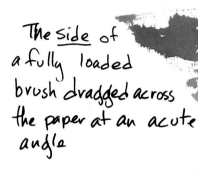

Spread hairs of a round brush for repeated marks

over a wash -- nice for hair, fur, textured wood, etc.

TIP

An alternate technique that goes somewhat faster is made by first spreading the hairs of the brush, as shown. You can **crosshatch** *strokes to make interesting color transitions.*

 Watercolor Dictionary: Crosshatching

Catch me using another odd word back in that last tip? *Crosshatching* is layers of tiny strokes that go in two directions or in several. You can build up as many layers as you like till you get the effect you want.

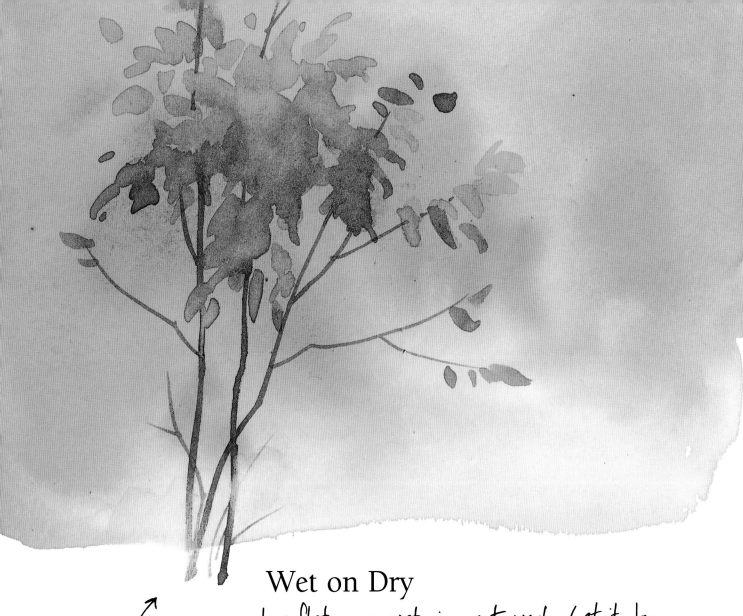

↗
lift to
blend

Wet on Dry

do a flat or a wet-in-wet wash. Let it dry completely, then add your subject in small or large washes.

TIP

You can always soften a too-harsh transition between the preliminary soft wash and later washes.

Try flooding a unifying tone over the top (wet an area with a shot of clean water from a spray bottle before adding color) or scrubbing a little along the hard edges with a damp brush or sponge wrung out in clear water.

Wet on Dry: This is a combination of techniques—again, rather like the Fear Conqueror. For this one, try to plan roughly where areas of color or of light and dark will go, and lay them in wet-in-wet. Allow them to dry, then add details on top to make sense of the image.

How to: Do a wet-in-wet wash, not trying to make it look like much of anything. Allow it to dry completely. Then, add the details you wish with glazes and small details.

Glazes

Glazing: This is an old technique that's especially suited to watercolor. Each layer is transparent to a degree (some pigments are more transparent than others), so it allows the underneath colors to show through; it's like stained glass.

How to: Lay down a tone of good, strong color; yellow, say. When it is completely dry, put down an overlying wash of Phthalo Blue. Just as we've always been told, there's green—and an especially nice, clear hue at that. Or, see what Alizarin Crimson looks like as a glaze over yellow or blue.

You can layer almost indefinitely, if you allow underlayers to dry completely—and if you work with a light, deft touch. (Otherwise, you may lift the underlayers and make mud of your wash.)

Glazes will work differently with pigments of different transparency. To get to know your pigments and what to expect, make a couple of stripes of India ink. Let them dry completely, then make a stripe of each of your colors. Let them dry, and you'll be able to see which colors are opaque and which are transparent.

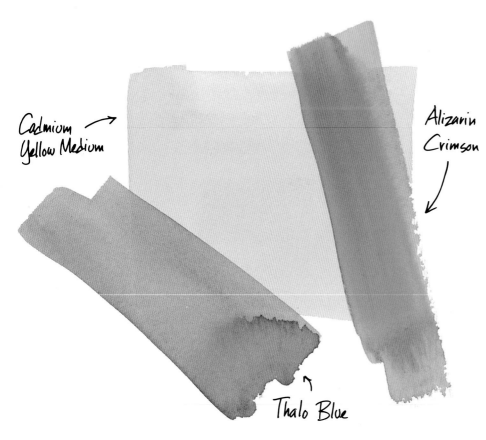

Cadmium
Yellow Medium

Alizarin
Crimson

Thalo Blue

allow to dry _thoroughly_ before adding another to avoid lifting & _MUD_.

> ## TIP
> *Glazes, which dry between layers of paint, allow for greater control than do splashy and wet-in-wet techniques. If you're having trouble with mud, you may want to give this technique a good try.*

Transparent and Opaque Colors

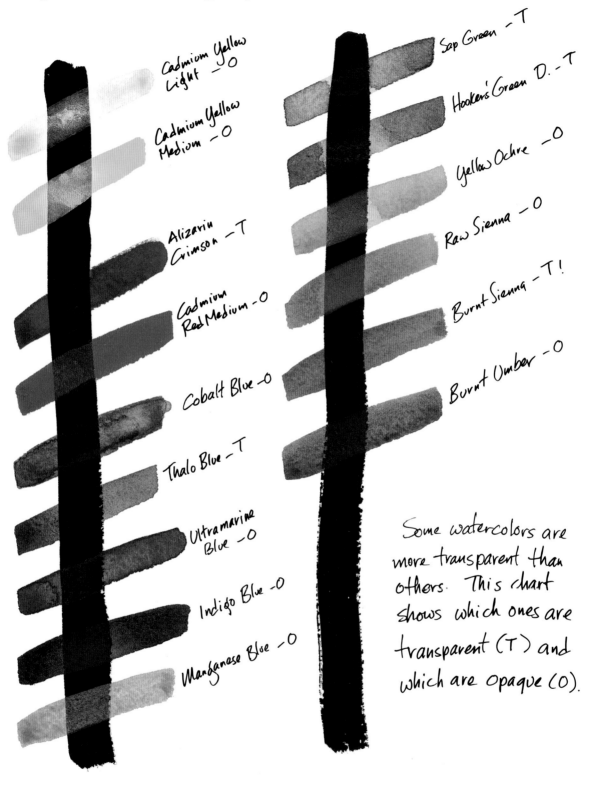

Cadmium Yellow Light — O

Cadmium Yellow Medium — O

Alizarin Crimson — T

Cadmium Red Medium — O

Cobalt Blue — O

Thalo Blue — T

Ultramarine Blue — O

Indigo Blue — O

Manganese Blue — O

Sap Green — T

Hooker's Green D. — T

Yellow Ochre — O

Raw Sienna — O

Burnt Sienna — T!

Burnt Umber — O

Some watercolors are more transparent than others. This chart shows which ones are transparent (T) and which are opaque (O).

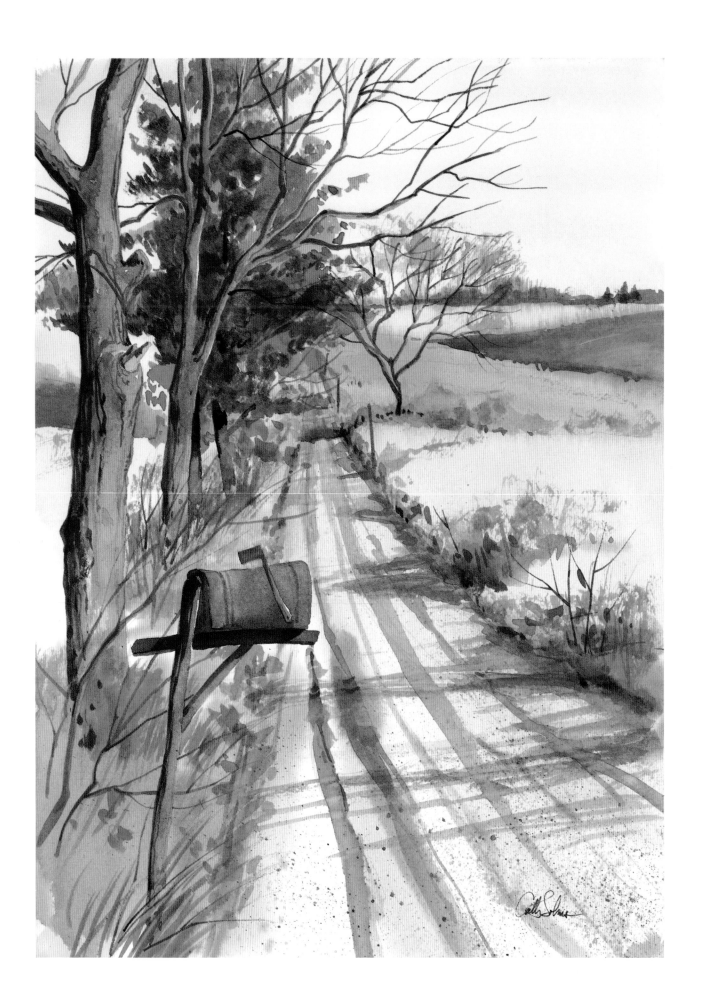

Chapter Three

HOW DO I PAINT...?

Finally—it's time to paint really recognizable stuff. (Although if I know artists, you've already turned some of those squiggles and practice runs into art. That's the nature of the beast; you can't hold creative people back!)

In this chapter we'll cover some of the subjects you'll end up painting often—landscapes, trees, rocks, barns, flowers, people. The subjects we've chosen are all around us; they're fairly easy and will get you off to a nonthreatening start. We'll explore water—still and moving—and the reflections objects cast in it. We'll take a look at how to paint believable skies, cloudless and otherwise. We'll practice painting a variety of trees through the seasons—with and without leaves. And, best of all, we'll do it all with simple, step-by-step instructions that are *logical* and *easy*. No great mysteries here.

We won't worry about details like composition and **value**. We're not going to be doing finished paintings just yet. We're only going to explore the specific elements that might *go into* a painting, then in chapter four, look at ways to put them together—again, step by logical step.

Try out these simple exercises; paint along, then take off on your own. You'll learn as much from your own explorations as from this "guided tour."

How to Paint a Tree

Let's look at trees, for example. Almost every landscape painting has to deal with them one way or another. Do a semigeneric tree from your imagination, just to get you off the ground. Watch for ways to use light and shadow to give form to your painted tree.

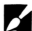
TIP

Remember that in life, tree trunks are very seldom warm brown (and almost never uniform in color or value). They're more of a grayish color; I mix Burnt Umber or Burnt Sienna with Ultramarine Blue in various mixtures to suggest trunks. Use value to suggest light, shadow and form.

Watercolor Dictionary: Value

This doesn't mean getting your money's worth, but refers to the shades of light and dark—the values—that make up a painting.

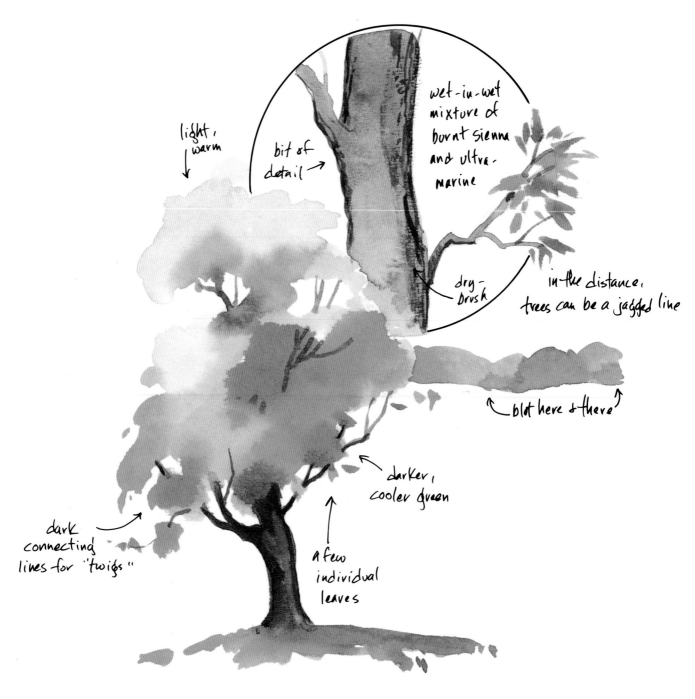

light, warm

bit of detail →

wet-in-wet mixture of burnt sienna and ultramarine

in the distance, trees can be a jagged line

dry-brush

blot here & there

dark connecting lines for "twigs"

darker, cooler green

a few individual leaves

A Variety of Tree Shapes

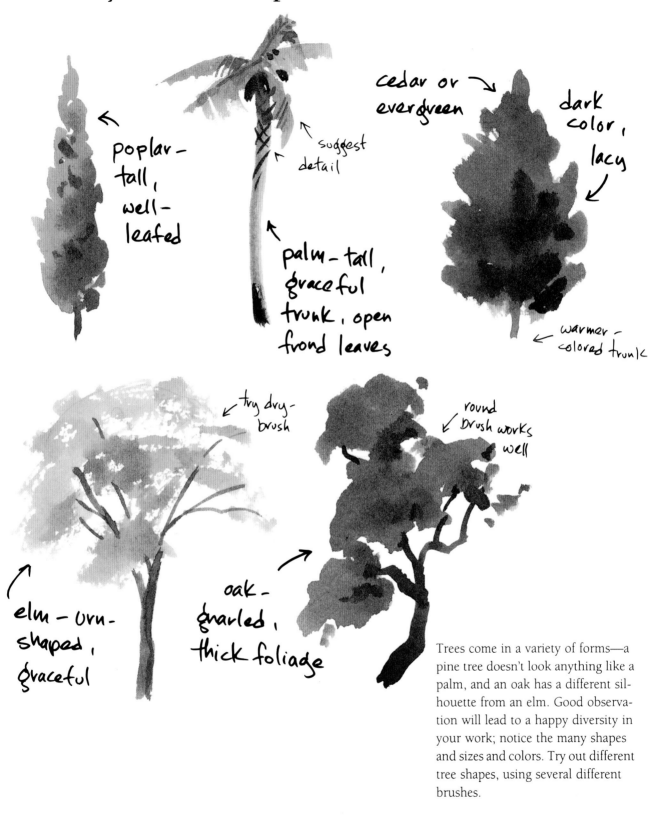

poplar – tall, well-leafed

suggest detail

palm – tall, graceful trunk, open frond leaves

cedar or evergreen

dark color, lacy

warmer-colored trunk

try dry-brush

round brush works well

elm – urn-shaped, graceful

oak – gnarled, thick foliage

Trees come in a variety of forms—a pine tree doesn't look anything like a palm, and an oak has a different silhouette from an elm. Good observation will lead to a happy diversity in your work; notice the many shapes and sizes and colors. Try out different tree shapes, using several different brushes.

Through the Seasons

Trees don't look the same all year long—not even if you forget about bare winter trees, which you don't want to do. In the spring, foliage is lacy, open, and much paler in color. In summer, it's dense and many shades of green, and in the fall, colors blaze. Explore these differences, remembering your practice in mixing colors.

TIP

Remember when you're painting bare winter trees that the twigs are smaller than the branches, the branches smaller than the limbs, and the limbs smaller than the trunk. Use smaller and smaller brushes to paint them, or a progressively lighter touch. Drybrush works well for tiny twigs.

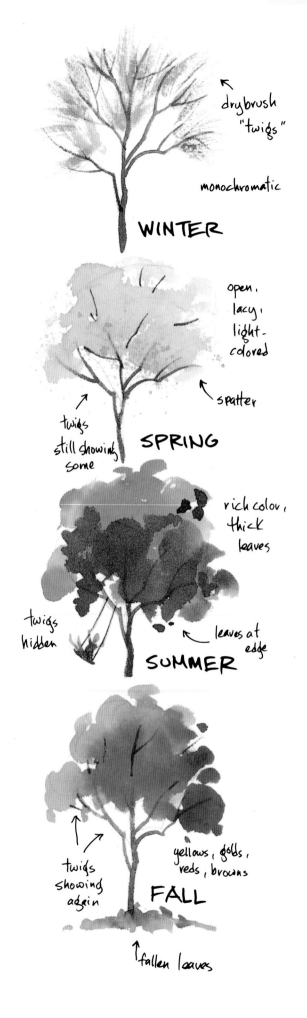

drybrush "twigs"

monochromatic

WINTER

open, lacy, light-colored

spatter

twigs still showing some

SPRING

rich color, thick leaves

twigs hidden

leaves at edge

SUMMER

twigs showing again

yellows, golds, reds, browns

FALL

fallen leaves

Three Ways to Paint Foliage

These exercises work as well for shrubs and bushes as they do for trees, of course. Try using a lacy dry-brush technique over a blob-shaped wash to suggest foliage, or jab with the tip of your barbered fan brush.

Try plastic wrap laid into a wet wash to suggest tree leaves, but don't leave it in place too long in this case; it can become very obvious.

Plastic wrap can be used for more than just tree leaves. Try it for rocky textures or weathered surfaces.

Allow it to remain for only a few moments for a softer effect, or overnight for something much more emphatic. Roll it up in a ball and stamp with it, if you like.

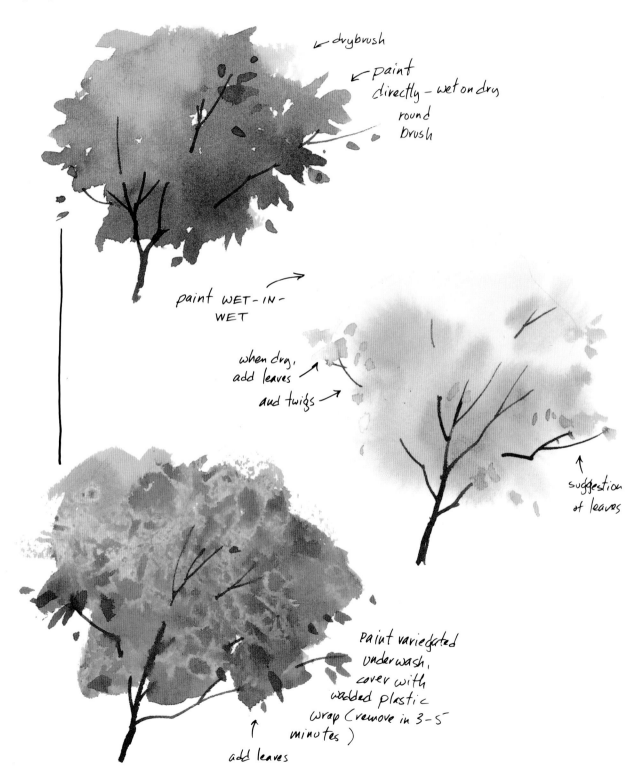

drybrush

paint directly – wet on dry round brush

paint WET-IN-WET

when dry, add leaves and twigs →

suggestion of leaves

Paint variegated underwash, cover with wadded plastic wrap (remove in 3–5 minutes)

add leaves

49

Tree Bark

Notice how much detail you can do without at a distance—a cool, varied wash will do. Add a bit more detail—perhaps drybrush—as you advance, and then paint as much as you like for foreground trees.

There's no need to settle for generic tree bark unless you just want to. Notice the differences, and explore ways to suggest these textures. Here, a young oak grows next to a wild plum. See how different they are?

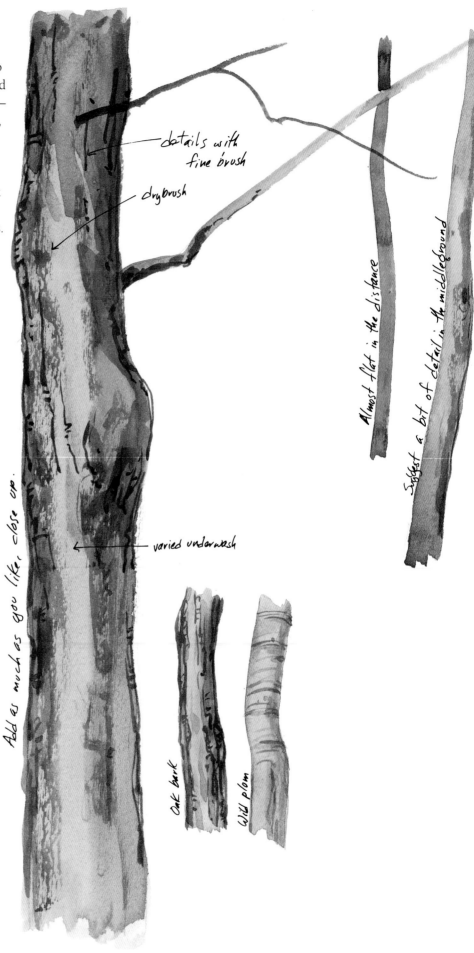

details with fine brush

drybrush

Almost flat in the distance

Suggest a bit of detail in the middleground

varied underwash

Add as much as you like, close up.

Oak bark

Wild plum

50

Grasses

Grasses and weeds are a constant in landscape painting; try out several versions, from short, spiky grasses painted in over a smooth wash, to tall, rough grasses. First, try out some simply painted short grass—the type you see in your lawn or park.

Remember, all grasses aren't green: Depending on season, or degree of rain, they may be any shade from green to gold, light to dark.

Notice how little detail you actually need to paint distant grasses. You can't see individual blades except in the foreground.

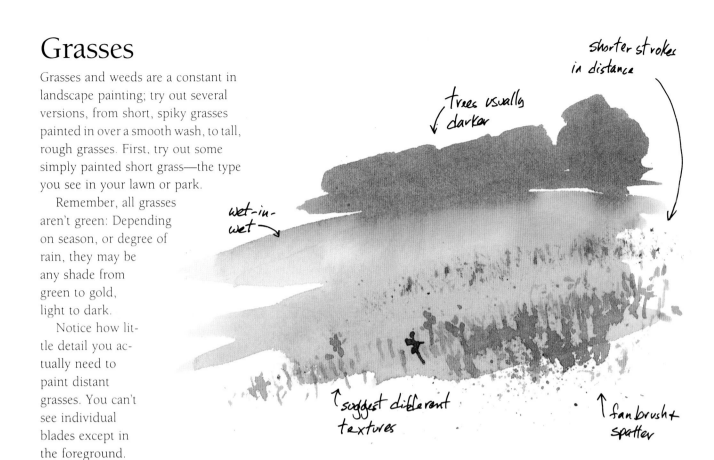

shorter strokes in distance

trees usually darker

wet-in-wet

suggest different textures

fan brush + spatter

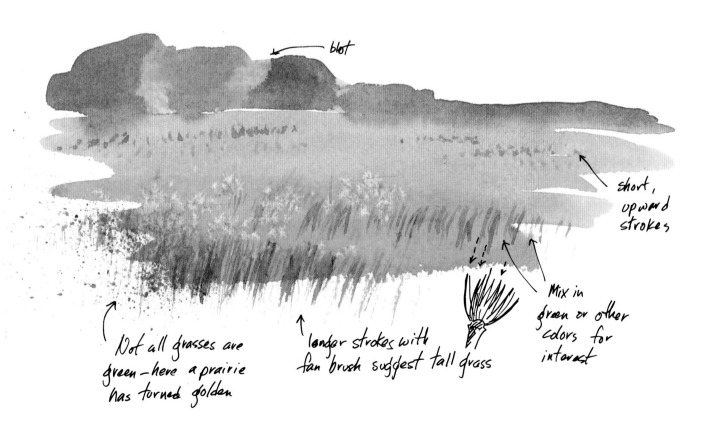

blot

short, upward strokes

Not all grasses are green—here a prairie has turned golden

longer strokes with fan brush suggest tall grass

Mix in green or other colors for interest

Rough Grasses

These are more interesting than golf-course greens. To achieve texture, try scraping through a wet wash, then through one that has begun to lose its shine.

Scraping is quite versatile; you can make light or dark lines—thick or thin—or scrape out fairly broad areas. It's useful for much more than just rough grasses, of course; you'll find a dozen ways to use this handy technique. Here's how:

1. Put down a good, strong wash, and while it's still wet, scratch through it with the end of your brush, a craft knife or your fingernail. The paper's fibers will be bruised, and you'll get a darker line where you've scraped.

2. Or, let the shine disappear somewhat and scrape with your tool held at an acute angle to the paper while your wash is still damp; some of the pigment will be moved out of the way, leaving a lighter area. Do this for light-struck limbs or grasses.

3. Let a wash dry completely and scratch through it with a sharp craft or pocket knife for some really sparkling linear effects. These *are* pure white, unlike those scraped lines, and they're nice for the glitter of sun on water, dew on a spider's web—use your imagination.

Take a closer look at your subject; unless they're on a manicured lawn, most grasses are interestingly mixed with tall and short, blade and broad-leaf. There's a variation in color as well.

1. Make a wet-in-wet shape for **local color**.

2. As it dries, scrape in light lines as you did with your rough grasses.

3. Now, add the details as you see them. Let yourself go—do as much or as little as you like.

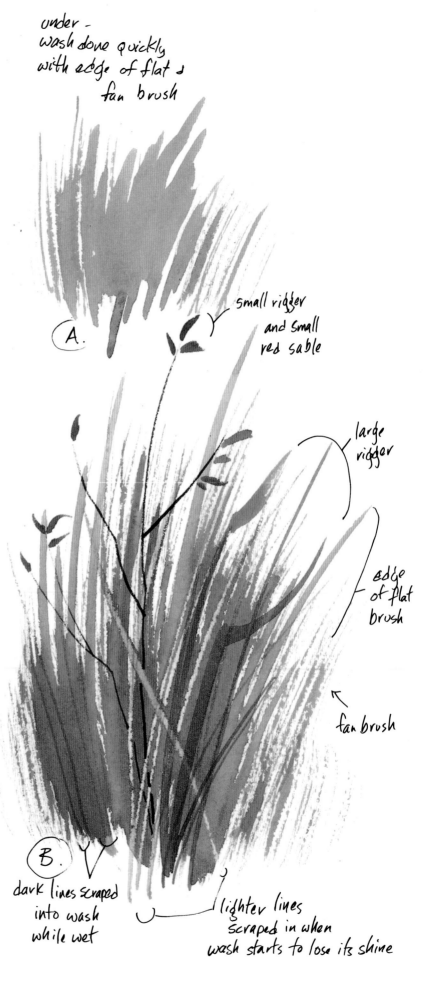

under-wash done quickly with edge of flat & fan brush

A.

small rigger and small red sable

large rigger

edge of flat brush

fan brush

B.

dark lines scraped into wash while wet

lighter lines scraped in when wash starts to lose its shine

Rough Grasses and Weeds

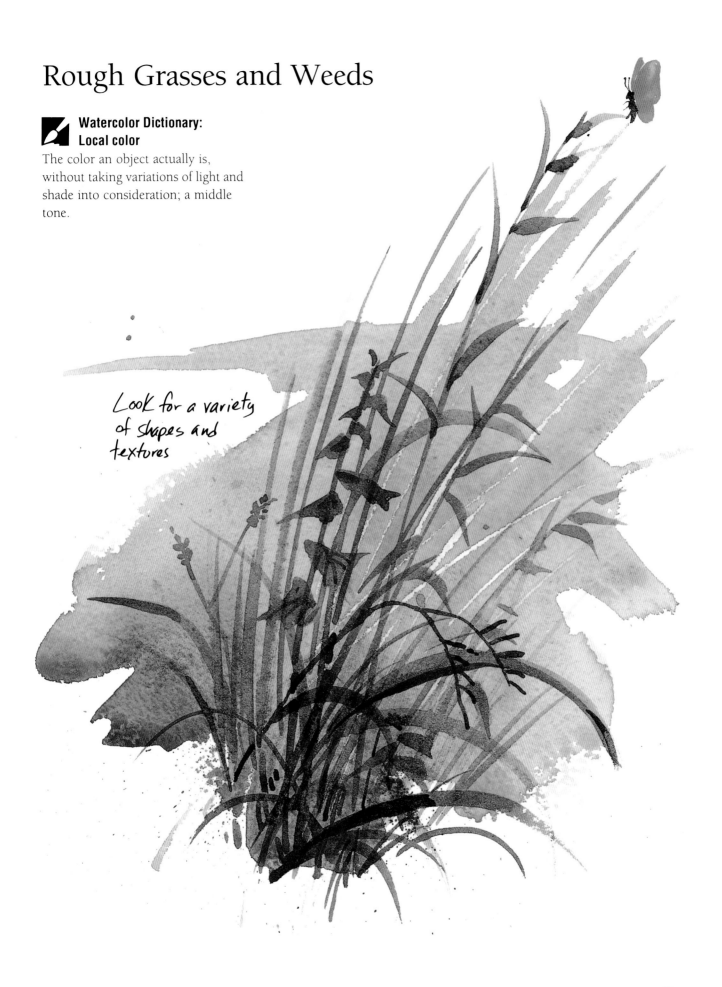

**Watercolor Dictionary:
Local color**

The color an object actually is,
without taking variations of light and
shade into consideration; a middle
tone.

*Look for a variety
of shapes and
textures*

Wet-In-Wet Skies

This technique works particularly well for skies. These can be soft, graduated tints of color (try a graded wash), cloud-filled expanses on a summer day—or heavy, gray forms threatening a storm.

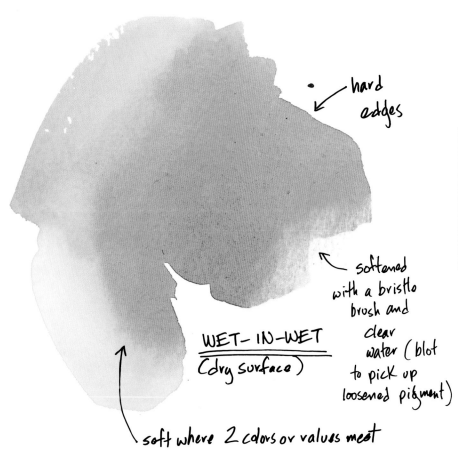

← hard edges

← softened with a bristle brush and clear water (blot to pick up loosened pigment)

WET-IN-WET
(dry surface)

↑ soft where 2 colors or values meet

TIP

Try using your largest brushes to paint the sky—and don't worry if it comes down into your background area. Soft transitions here suggest distance.

← nice, soft flow

WET-IN-WET
(wet surface)

↑ soft edges

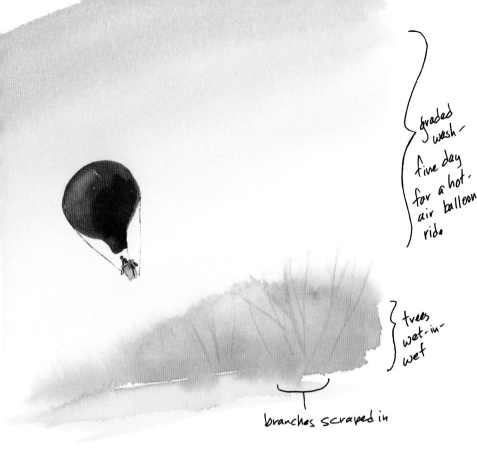

graded wash - fine day for a hot-air balloon ride

trees wet-in-wet

branches scraped in

Skies (cont.)

You can get a wonderful night-sky effect if you lay in a dark wash, then sprinkle it *sparingly—and irregularly*—with salt. Allow the wash to dry, then brush away excess salt, which will have pushed the pigment out of the way and left light sparkles.

Pick out a few stars with sharp craft knife

masked out moon with masking tape — remove when DRY

Wet-in Wet is great for skies:

This technique works particularly well for skies. These can be soft, graduated hues of color (try a graded wash), cloud-filled expanses on a summer day—or a threatening storm.

strong wash of thalo + ultramarine grading to aliz. crimson

tree scraped in while damp

Salt added while fairly wet - paper is still glossy, not wet-wet shine.

Tissue Tricks

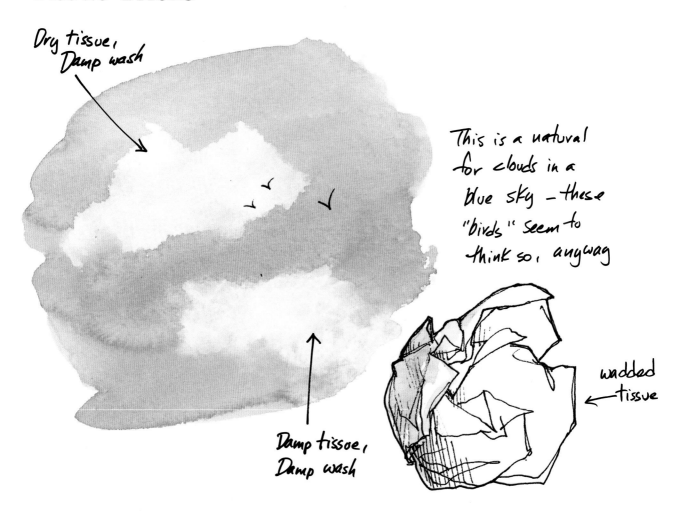

Dry tissue, Damp wash

This is a natural for clouds in a blue sky — these "birds" seem to think so, anyway

Damp tissue, Damp wash

wadded tissue

Try a wet or dry paper towel, a facial tissue or a sponge, to **lift** or **blot** clouds from your wet wash.

TIP

If you've forgotten to paint around your clouds—or to blot or to lift them while damp—no problem. Wet a sponge with clean water and scrub the desired area until you get the shape you want. Blot immediately with a paper towel to lift unwanted pigment.

 Watercolor Dictionary: Lift, Blot

To remove a bit of color from your paper's surface, wet or dry. Use a dry paper towel or a damp one for hard edges or soft; a damp sponge does the same thing.

Cloudy Sky

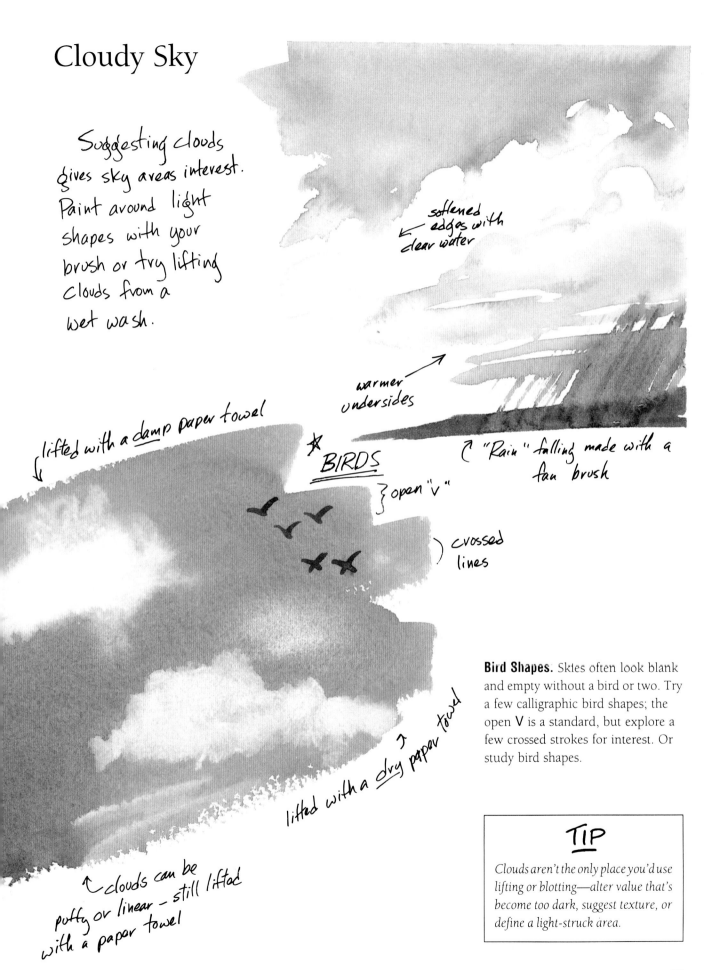

Suggesting clouds gives sky areas interest. Paint around light shapes with your brush or try lifting clouds from a wet wash.

softened edges with clear water

warmer undersides

lifted with a damp paper towel

✷ BIRDS

} open "v"

) crossed lines

⌒ "Rain" falling made with a fan brush

lifted with a dry paper towel

↶ clouds can be puffy or linear – still lifted with a paper towel

Bird Shapes. Skies often look blank and empty without a bird or two. Try a few calligraphic bird shapes; the open **V** is a standard, but explore a few crossed strokes for interest. Or study bird shapes.

TIP

Clouds aren't the only place you'd use lifting or blotting—alter value that's become too dark, suggest texture, or define a light-struck area.

Water

Still Water: Try a smooth, nearly windless expanse of water. A graded wash might work well here—go for a two-color effect. A little dry-brush work suggests the sparkle of light on water.

STILL WATER

flat horizon line

wet-in-wet underwash

drybrush—
dark & light
for texture

> ## TIP
>
> *Sometimes this technique works best on rough paper. If you are using cold-press, you'll need to use the side of your brush rather than the point to get a similar effect.*

Reflections in Water: Now, try adding reflections. Remember that they lean at the same angle as their object and that they are often darker than their object. Try your rigger brush over a wash of rich color for squiggly reflections.

REFLECTIONS
IN WATER

for trees &
their reflections —
wet-in-wet
- - - - shore line

reflections hold
their shape
close to their
object, then
break up

wet-on-dry reflections

58

Wet-In-Wet With Drybrush

Adrop of clear water fell in my wash - call it "sun through mist!"

1. - apply a wet-in-wet or graded wash (this one goes from sunset orange to twilight purple.)

← open, light-struck area created by changing the angle of the brush - now held close to the paper

Believe it or not, painting water is a great place to use drybrush—as well as graded washes. Try a graded wash as an underwash, maybe including a dry-brush passage or two to suggest the sparkle of light on water. Allow it to dry, and add a bit of dry-brush work, as shown.

2. - let dry and add drybrush for texture

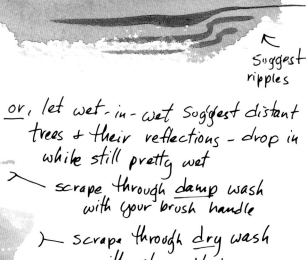

Suggest ripples

or, let wet-in-wet suggest distant trees + their reflections - drop in while still pretty wet

↗ scrape through damp wash with your brush handle

↗ scrape through dry wash with sharp blade

Calligraphic Brushstrokes

Round red sable ↗

Try out various effects for moving water—look to see how your round brush can suggest calligraphic movement. The flat brush works well here, too, for thick and thin lines.

Flat brush

Line scraped out with brush handle

Then, try lifting and scraping to suggest foam, spray and movement

(Wet wash)

Lift with damp paper towel

Moving Water

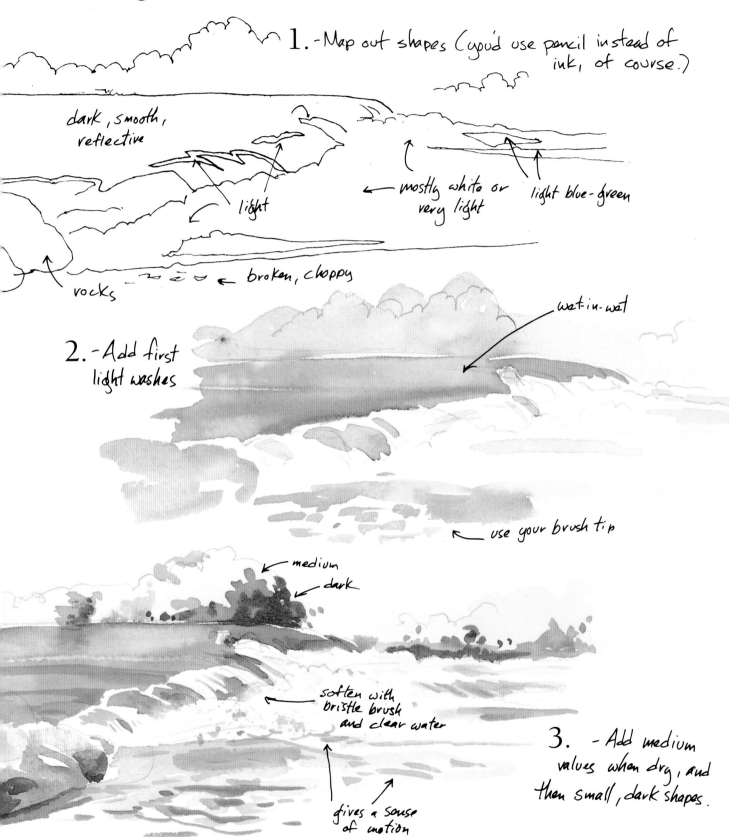

1. - Map out shapes (you'd use pencil instead of ink, of course.)

dark, smooth, reflective

light

mostly white or very light

light blue-green

rocks

broken, choppy

2. - Add first light washes

wet-in-wet

use your brush tip

medium

dark

soften with bristle brush and clear water

gives a sense of motion

3. - Add medium values when dry, and then small, dark shapes.

Moving Water—Surf

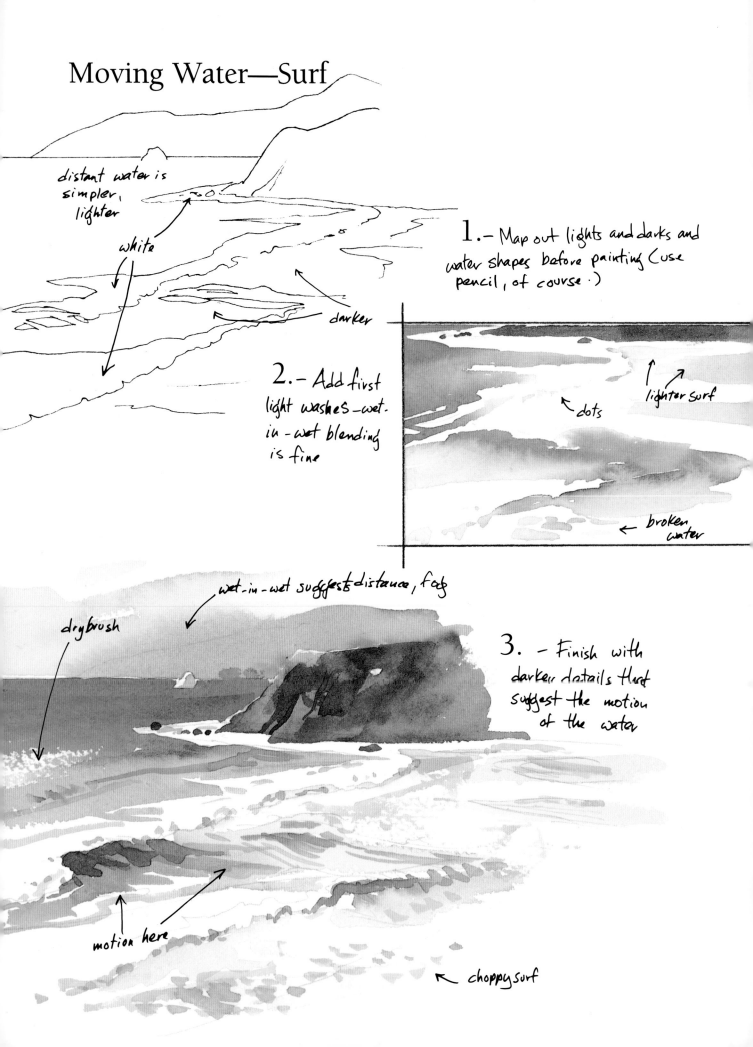

distant water is simpler, lighter

white

darker

1.— Map out lights and darks and water shapes before painting (use pencil, of course.)

2.— Add first light washes—wet-in-wet blending is fine

dots

lighter surf

broken water

wet-in-wet suggests distance, fog

drybrush

3. — Finish with darker details that suggest the motion of the water

motion here

choppy surf

Falling Water

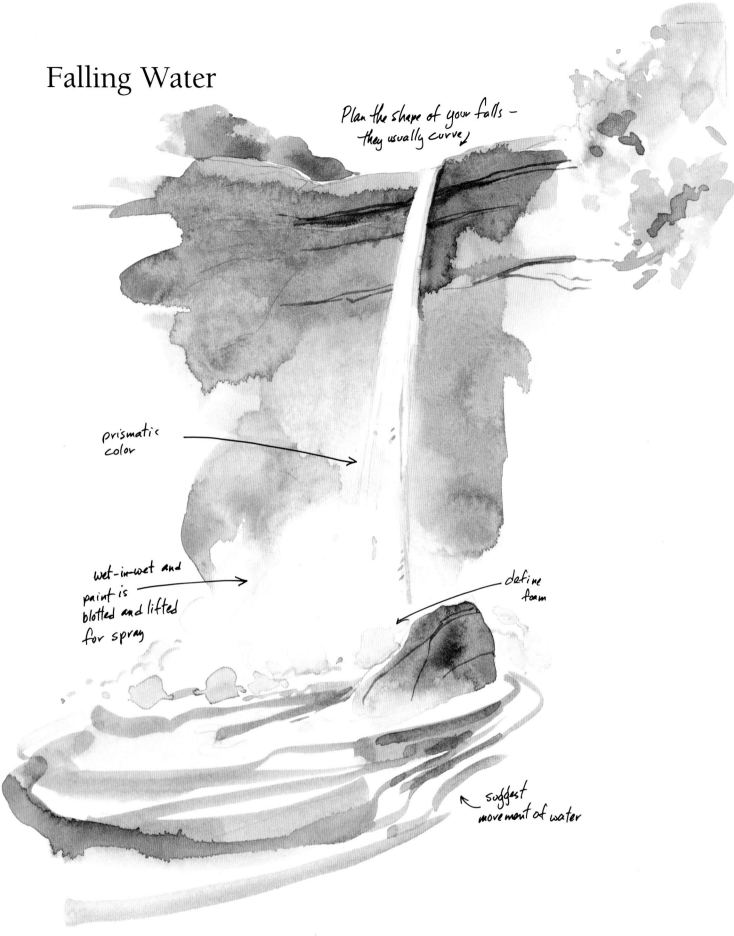

Plan the shape of your falls — they usually curve

prismatic color

wet-in-wet and paint is blotted and lifted for spray

define foam

suggest movement of water

Remember to look for shadows <u>behind</u> the waterfall.

Snow—Prismatic Effects

A winter scene is fun to paint—subtle and sophisticated. Remember, snow is not just blank paper. Suggest the shape of the land with light and shadows, and use cast shadows to reinforce that suggestion.

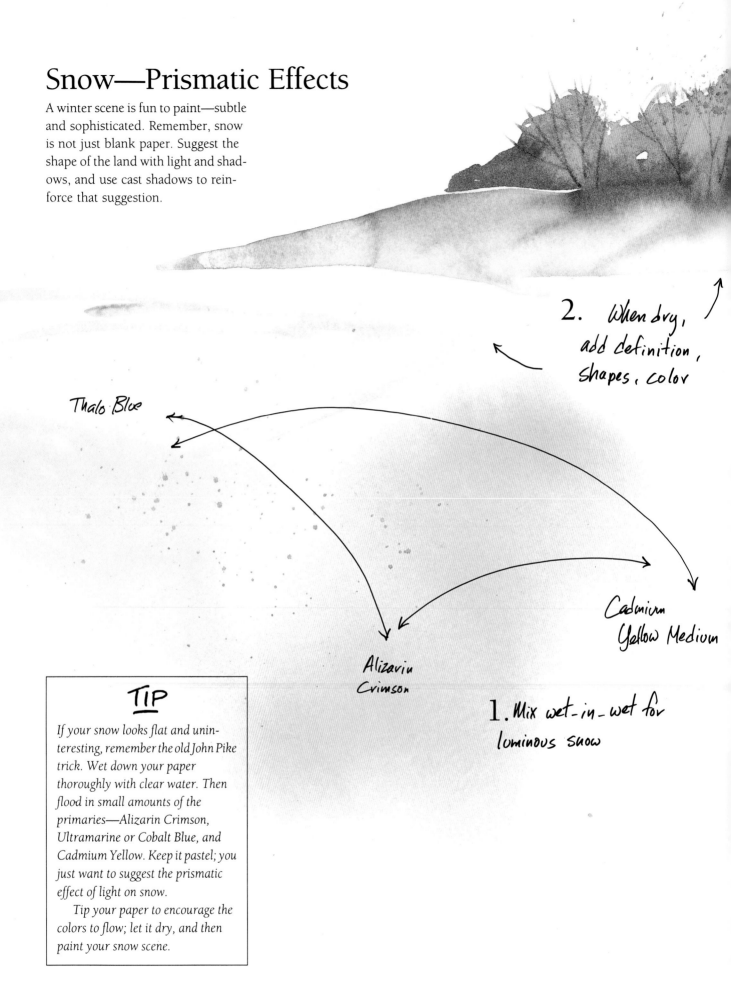

2. When dry, add definition, shapes, color

Thalo Blue

Cadmium Yellow Medium

Alizarin Crimson

1. Mix wet-in-wet for luminous snow

TIP

If your snow looks flat and uninteresting, remember the old John Pike trick. Wet down your paper thoroughly with clear water. Then flood in small amounts of the primaries—Alizarin Crimson, Ultramarine or Cobalt Blue, and Cadmium Yellow. Keep it pastel; you just want to suggest the prismatic effect of light on snow.

Tip your paper to encourage the colors to flow; let it dry, and then paint your snow scene.

Snow

Sprinkle salt into a
wet wash

Let dry, then brush
away excess

Spatter over
dry wash

OPAQUE
SPATTER

Wet-in-wet

SHADOWS

1. – Draw in overall shape and lay light preliminary wash

2. – Add wet-in-wet color variations –here, yellow ochre and burnt sienna

3. – Begin to define shadows and add texture – added ultramarine blue and spatter

4. – Add final sharp, dark details

Mountains, Cliffs and Other Rock Forms

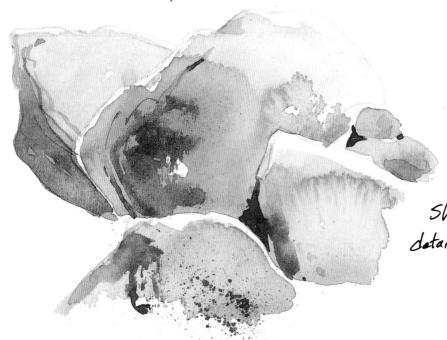

Rock formations, cliffs and mountains appear often in landscapes. Learning how to suggest their forms and textures can help you to create a believable painting.

Shadows and small details help define rock shapes

Spatter

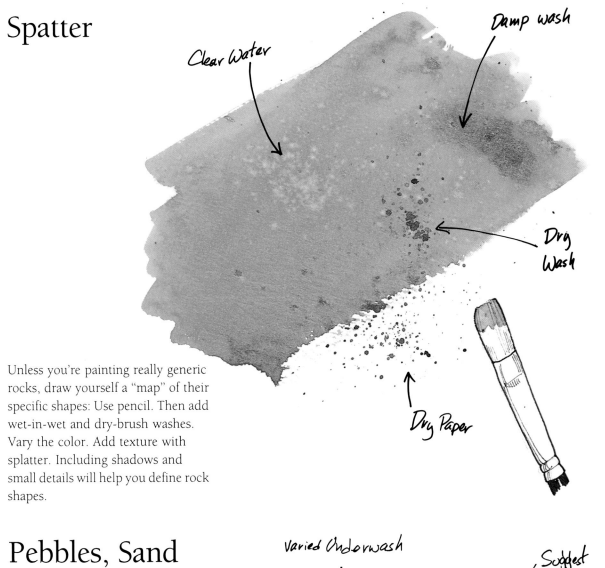

Clear Water

Damp wash

Dry Wash

Dry Paper

Unless you're painting really generic rocks, draw yourself a "map" of their specific shapes: Use pencil. Then add wet-in-wet and dry-brush washes. Vary the color. Add texture with splatter. Including shadows and small details will help you define rock shapes.

Pebbles, Sand

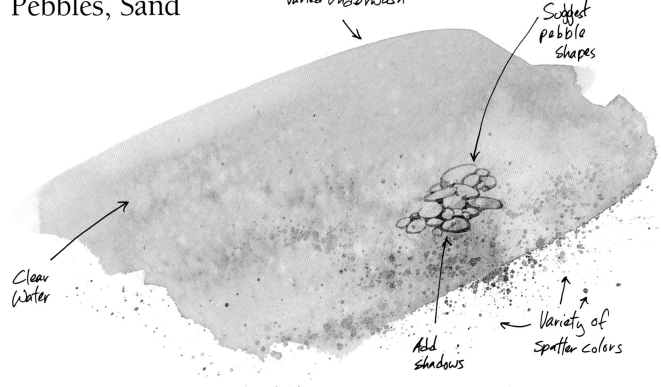

Varied Underwash

Suggest pebble shapes

Clear Water

Add shadows

Variety of spatter colors

Settling (Sedimentary) Colors

This is one of the interesting phenomena of nature—metal that oxidizes and takes on wonderful texture and color. Try mixing the **sedimentary** colors so your "rust" will separate into granules naturally.

Putting buildings in a landscape can be easy; for the most part, you're not starting out with the Taj Mahal—or even the Pentagon.

Burnt Umber

Ultramarine Blue

note settling

Burnt Sienna

note settling

Manganese Blue

Ultramarine Blue

Burnt Umber

note settling here!

Watercolor Dictionary: Sedimentary

Sedimentary pigments tend to separate or granulate interestingly. Those colors most likely to settle are the earth colors (the browns, especially Burnt Umber), as well as Ultramarine, Cobalt and Manganese Blue. They make nice grays and browns and can be used in a variety of ways.

Rusty Metal

1. – Preliminary Wash of "local color"

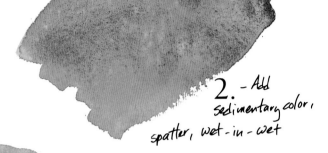

2. – Add sedimentary color, spatter, wet-in-wet

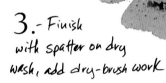

3. – Finish with spatter on dry wash, add dry-brush work

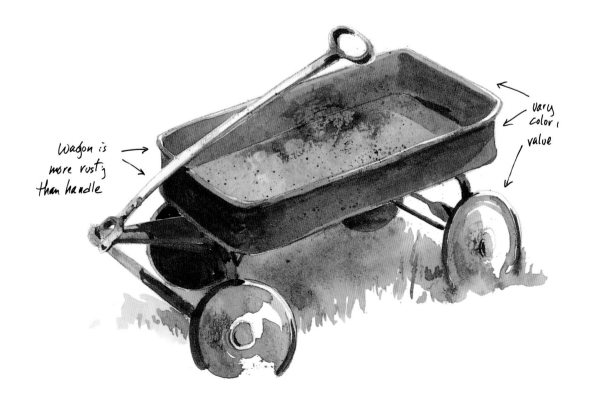

Wagon is more rusty than handle

Vary color, value

Buildings in Landscape

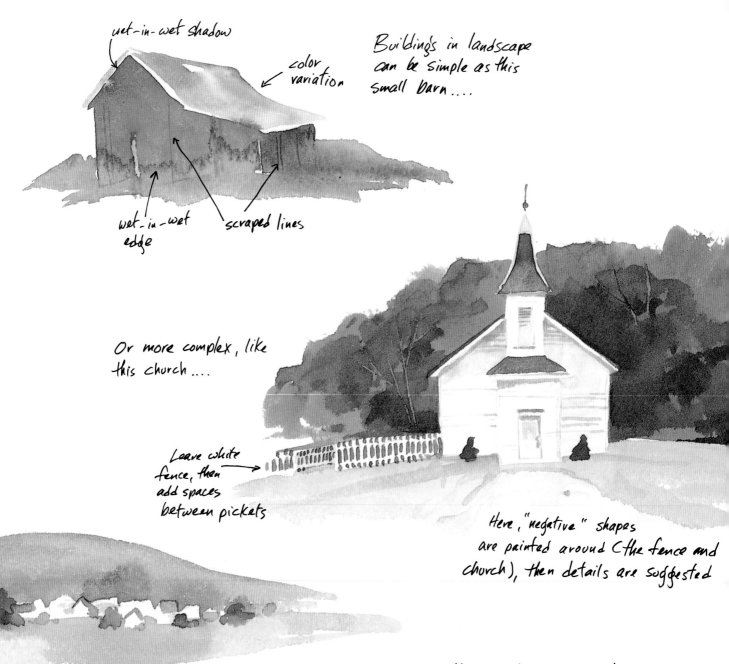

wet-in-wet shadow

color variation

Buildings in landscape can be simple as this small barn....

wet-in-wet edge

scraped lines

Or more complex, like this church....

Leave white fence, then add spaces between pickets

Here, "negative" shapes are painted around (the fence and church), then details are suggested

Buildings in the distance, like this rural village, can be extremely simple — just suggest a few shadows and roof colors.

Putting buildings in a landscape can be easy; for the most part you're not starting out with the Taj Mahal — or even the Pentagon.

Liquid Maskoid

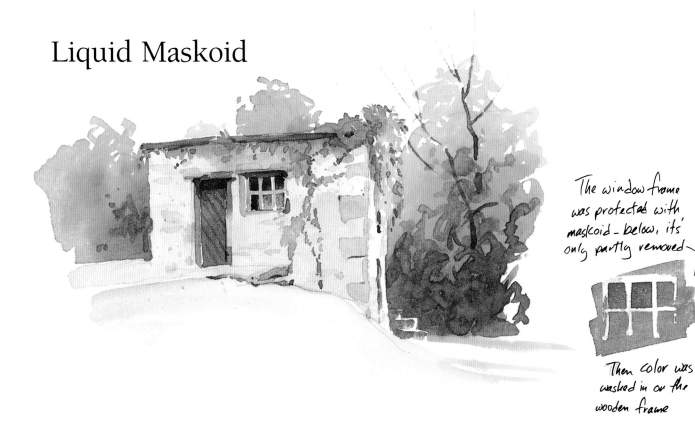

The window frame was protected with maskoid - below, its' only partly removed

Then color was washed in on the wooden frame

Mask out a window or door before starting your subject, if you like, with a liquid **masking agent**. Then, you can go back in later and add a touch of color if it looks too stark.

This is really much like painting water, believe it or not. Map out the shape of the reflections, and remember to watch for reflected lights. These will give color and life to your painting.

When you paint things with an opaque, matte or dull surface, you see the form without the highlights. Look for ways to suggest roundness or form.

◨ Watercolor Dictionary: Masking agents

(Maskoid, Misket, Incredible White Mask, frisket) are rubber in liquid form used to preserve important lights while you do loose, free overwashes. It's often easier than trying to paint around them. (Let the masking agent dry completely before painting over it; then remove it when the painting is dry.)

TIP

A rubber-cement pickup (a small square of crepe rubber) will remove Maskoid. It's easier on your paper surface and more precise than rubbing it off with your fingers.

Cutting in half gives you sharper corners to pick up small bits

Flowers at a Distance

This in liquid mask

dropped into
wet wash

Allowed to
dry befor painting

Salt gives a more abstract effect, just a soggestion of flowers here

Opaqoe white mixed with watercolors offers variety and softness...

...but loses transparency

Flower Shapes

1. Make a rough overall shape

Note how the shape changes with the angle

2. Add petal shapes, carefully observed — lay in wet-in-wet color

3. When dry, add final details

Many flowers follow the same basic shape — these are wild pinks

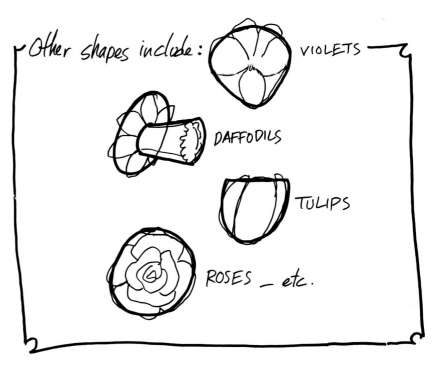

Other shapes include:

VIOLETS

DAFFODILS

TULIPS

ROSES _ etc.

Painting Fruit

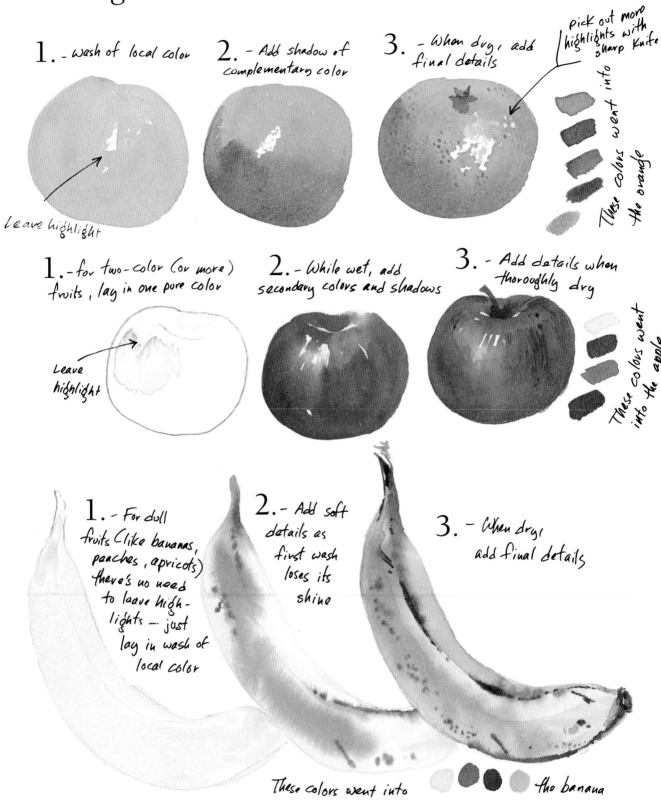

1. – wash of local color

2. – Add shadow of complementary color

3. – When dry, add final details

pick out more highlights with sharp knife

Leave highlight

These colors went into the orange

1. – for two-color (or more) fruits, lay in one pure color

Leave highlight

2. – While wet, add secondary colors and shadows

3. – Add details when thoroughly dry

These colors went into the apple

1. – For dull fruits (like bananas, peaches, apricots) there's no need to leave highlights – just lay in wash of local color

2. – Add soft details as first wash loses its shine

3. – When dry, add final details

These colors went into the banana

Fruit—Slightly More Complex

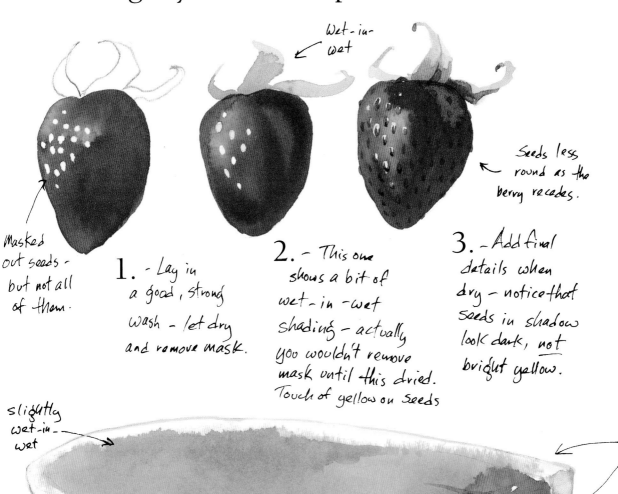

Wet-in-wet

Masked out seeds - but not all of them.

1. - Lay in a good, strong wash - let dry and remove mask.

2. - This one shows a bit of wet-in-wet shading - actually you wouldn't remove mask until this dried. Touch of yellow on seeds

3. - Add final details when dry - notice that seeds in shadow look dark, not bright yellow.

Seeds less round as the berry recedes.

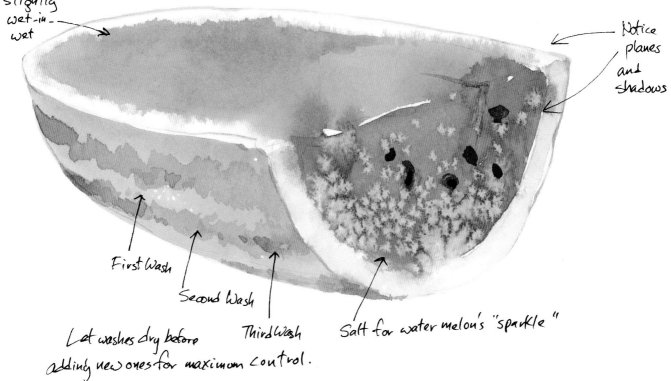

slightly wet-in-wet

Notice planes and shadows

First Wash

Second Wash

Third Wash

Salt for watermelon's "sparkle"

Let washes dry before adding new ones for maximum control.

Shiny Things

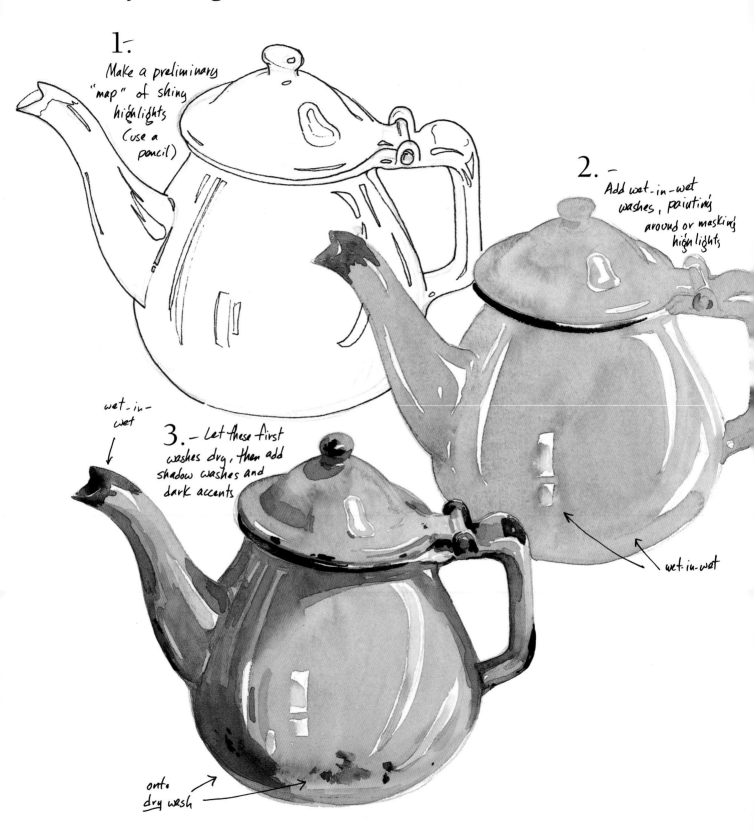

1. Make a preliminary "map" of shiny highlights (use a pencil)

2. Add wet-in-wet washes, painting around or masking highlights

wet-in-wet

3. — Let these first washes dry, then add shadow washes and dark accents

wet-in-wet

onto dry wash

Dull (non-shiny) Things

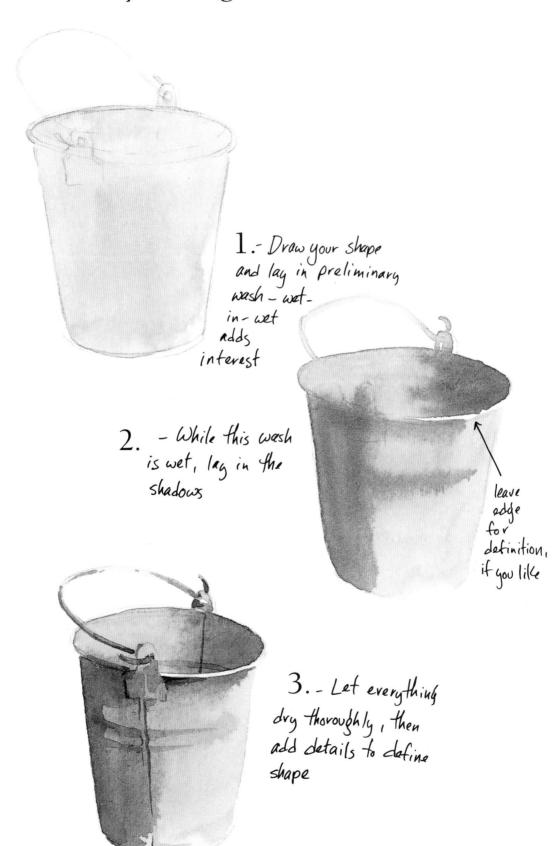

1.- Draw your shape and lay in preliminary wash – wet-in-wet adds interest

2. - While this wash is wet, lay in the shadows

leave edge for definition, if you like

3. - Let everything dry thoroughly, then add details to define shape

Animals in Close-Up

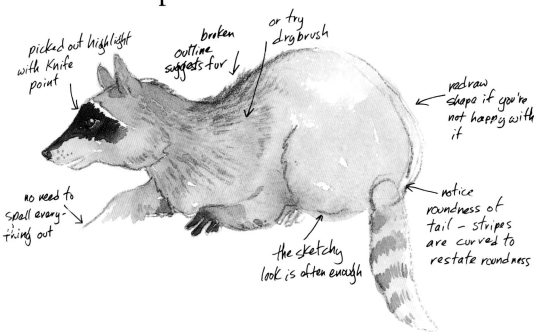

picked out highlight with knife point

broken outline suggests fur

or try drybrush

no need to spell everything out

redraw shape if you're not happy with it

the sketchy look is often enough

notice roundness of tail – stripes are curved to restate roundness

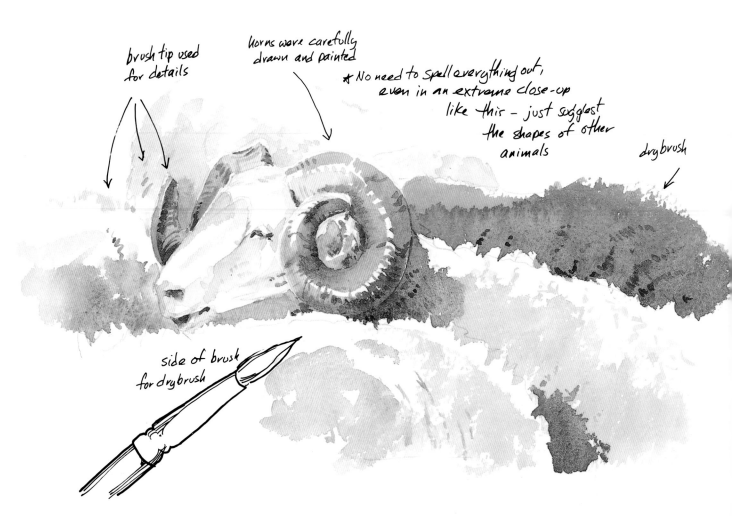

brush tip used for details

horns were carefully drawn and painted

*No need to spell everything out, even in an extreme close-up like this – just suggest the shapes of other animals

drybrush

side of brush for drybrush

A Variety of Bird Shapes and Sizes

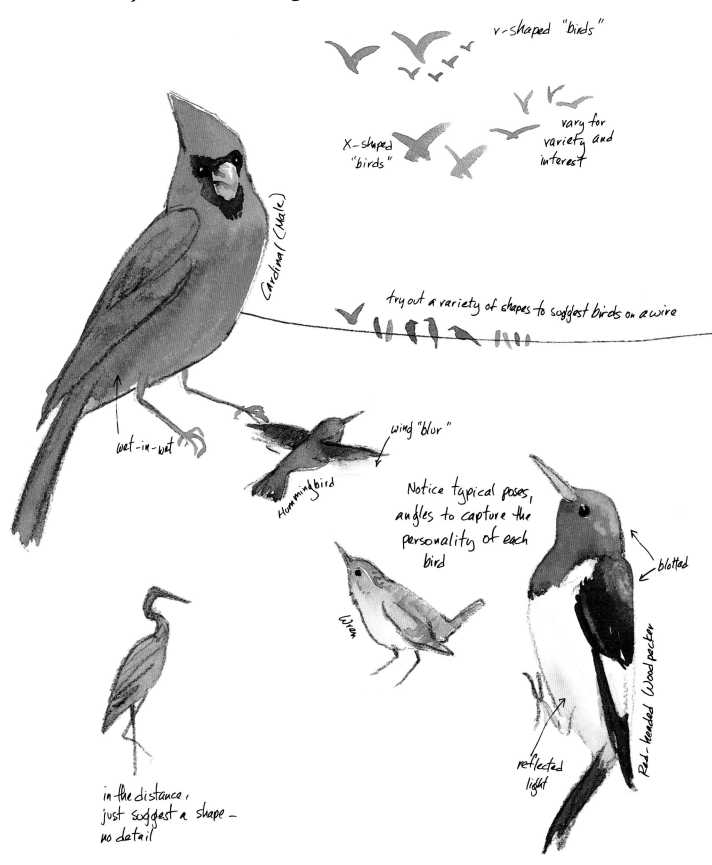

v-shaped "birds"

X-shaped "birds"

vary for variety and interest

Cardinal (Male)

try out a variety of shapes to suggest birds on a wire

wet-in-wet

wing "blur"

Hummingbird

Notice typical poses, angles to capture the personality of each bird

blotted

Wren

Red-headed Woodpecker

reflected light

in the distance, just suggest a shape — no detail

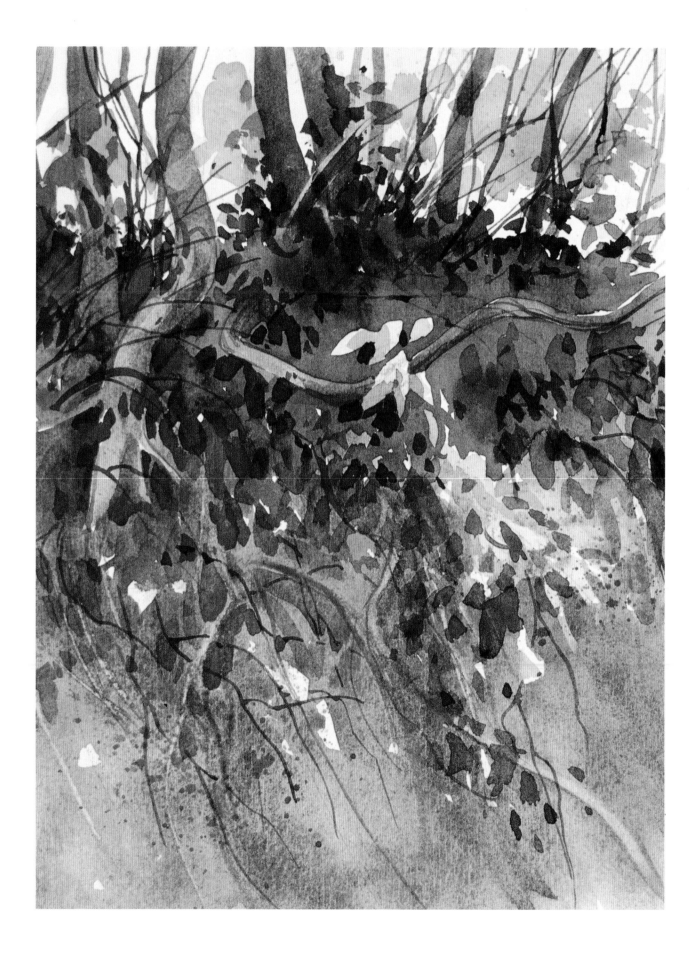

Chapter Four

STEP-BY-STEP DEMONSTRATIONS

By now you're confident, ready and anxious!—to put all this together into a finished painting. In fact, with all the practice you've gotten and the exploration you've done, you hardly need any guidance. (You may already have forged on ahead, and more power to you!)

Let's look at a few basics that will get you started in the right direction: how to plan a composition or a good, strong value pattern; what to paint first; and how to follow that first wash to its logical conclusion. We'll also explore some ways to sharpen your drawing skills while painting.

Again, we'll use simple, step-by-step illustrations to act as signposts on your way as we explore your first landscape, fall scene, still life and others.

Do I Need to Know How to Draw?

Of course it helps to have basic drawing skills, but you can get a lot of mileage—and a lot of learning—out of just jumping in and getting to know the medium. Then you can learn to capture the basic shapes to help you create the effects you want.

Simple drawing skills aren't difficult to come by. Drawing—sketching, doodling, getting those basics down on paper—is fun, and it's good exercise in seeing. (See the bibliography for some good books on simple drawing techniques.)

How Can I Learn to Draw Better by Painting?

There are two main ways that painting can help you draw better. The more literal approach is by practicing with your brush as though it were a pencil. In other words, draw with it.

Use a brush with a point rather than a flat one for this purpose, and have at it. Your creation can be as simple or as complex as you want—just give it a try and see how interesting those varied lines can be. Lots of artists use a calligraphic technique; it's like doodling with a brush.

The other way painting will teach you to draw better is by the simple trial-and-error of learning. As you paint, you'll find that you *want* to sketch—to think out your composition, or to capture some detail to paint later.

When you finish a painting and something just doesn't look right, analyze your basic shapes, or check perspective. We can often tell when something is wrong just by looking: Seeing it down on paper will help you to tell what that is.

VALUE SCALE

Practice mixing the various tints and shades that give your work form and believability.

TIP

If you have trouble analyzing your paintings yourself (and we're often too close to our own work to find any but the most obvious flaws), ask someone whose opinion you trust—a teacher or another artist, not your doting parents or loving spouse, obviously!

Planning Ahead

Remember that with watercolor, you do generally need to plan ahead, especially if there are areas of white you'll need to mask out or paint around—that is, if you have a specific destination. (Some artists simply begin painting and let the effects that happen suggest subject or directions.)

Think of your painting as a stage set. First, decide your lightest lights and darkest darks. Then, the background can be the next lightest shade: When you begin to paint, keep it simpler and bluer, too. Middle ground can be mostly middle tones, and the foreground—or whatever you've chosen for your center of interest—can contain the most detail as well as the extremes of light and dark or bright color.

Make a value scale to see the range your colors are capable of; make one for each color, if you like.

A Five-Value System

Making a small, thumbnail sketch on a piece of scrap paper first lets you plan ahead. Here, you can explore the basics of composition or value before starting in on that white paper. (One value should dominate a painting—for instance, you might make it mostly dark with some medium and a bit of light value. Otherwise, your painting can get boring or confusing—it may look more like a camouflage T-shirt than a piece of art!)

Don't try to include every nuance of light and dark when you plan your value system. Look at your subject carefully—dark glasses or a piece of tinted Plexiglas may help you to simplify values; so does squinting. Just go for the basic shapes, here—don't worry about details.

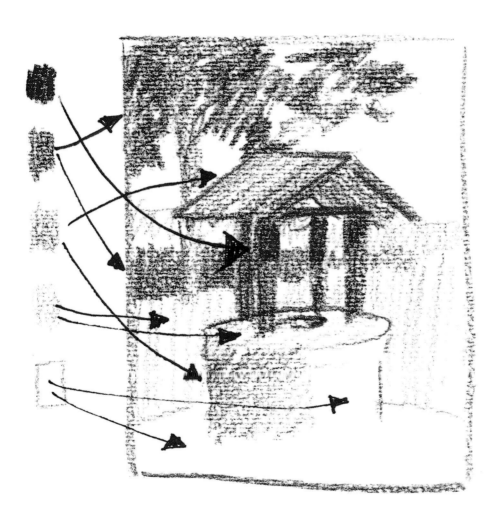

Let One Value Dominate Your Painting

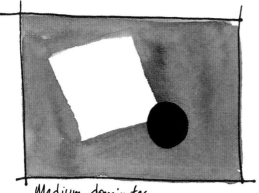

Medium dominates

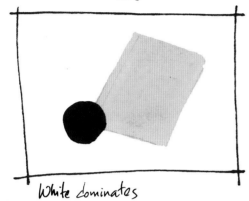

White dominates

It doesn't matter whether it's mostly light, mostly dark, or mostly a middle value — but somebody's got to take charge!

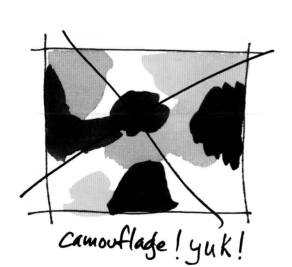

Camouflage! yuk!

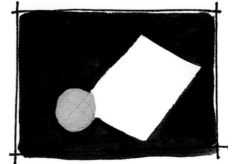

In watercolor, letting your darks dominate is dramatic — and more difficult!

Considering Composition

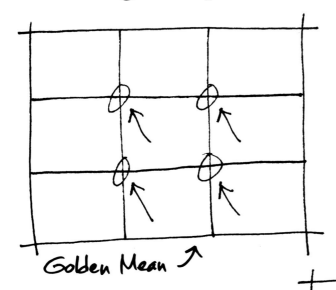

Golden Mean ↗

Here, two forms are too much alike in size and in placement — vary one or the other, & move one away from the Golden Mean. ▼

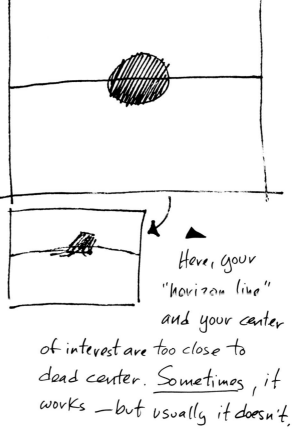

Here, your "horizon line" and your center of interest are too close to dead center. Sometimes, it works — but usually it doesn't.

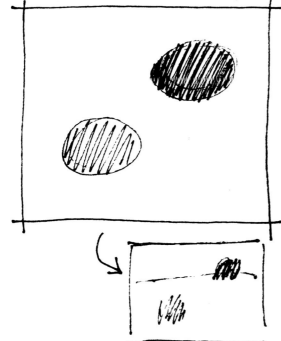

Sketching Outdoors

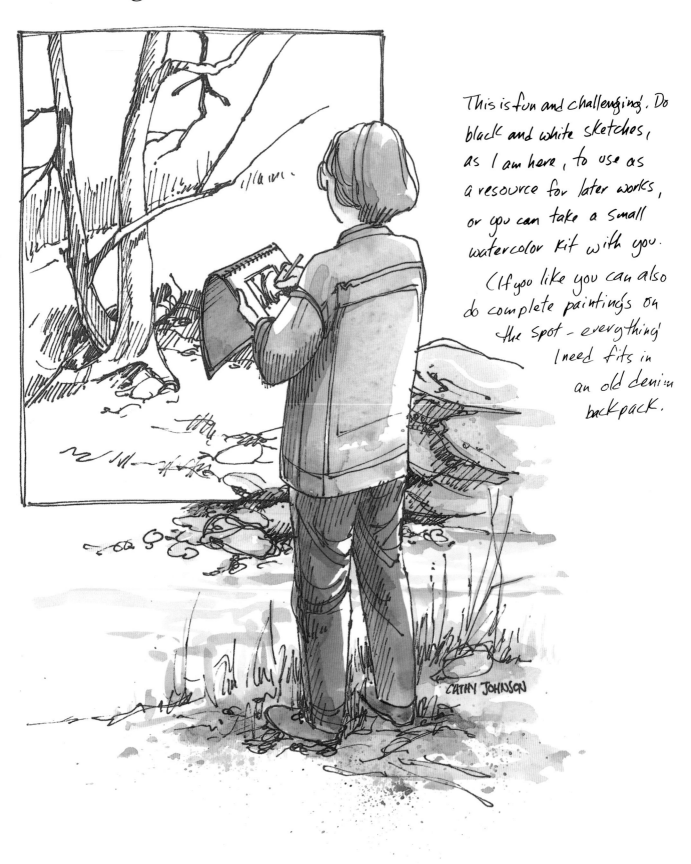

This is fun and challenging. Do black and white sketches, as I am here, to use as a resource for later works, or you can take a small watercolor kit with you.

(If you like you can also do complete paintings on the spot - everything I need fits in an old denim backpack.

CATHY JOHNSON

Keeping a Sketchbook

Though you may not have thought of it this way, keeping a sketchbook is one of the most pleasurable—and useful–things an artist can do. It's your diary of your life as a creative person, recording your days, your experiences. It's great for keeping your impressions of your travels all in one place.

My own sketchbook has evolved far beyond simply drawing things that I might paint from later. It's an end in itself, an integral part of my life. I draw the people who wait in line with me, or the squirrel that visits my bird feeder. I pass the time at the doctor's office with my pencil in hand. My sketchbook is also a journal of natural-history observations, as well as a research tool. Here, in addition to my quick sketches, doodles and planning diagrams, I keep notes about a museum I've visited, names of people I may want to contact, reminders of my assignments and appointments—even my grocery list! It's better than an executive's day-planner; it's a *lot* more fun. This is one practice I heartily recommend.

Sketching Outdoors

Of course sketching on the spot can be intimidating—there's a lot going on, and there's no way to get it all down. Don't worry about it! Simplify what you see: Make a value sketch, or zero in on one detail. Squint your eyes to simplify patterns of light and dark as well as all those details.

Once you've decided on a subject and a composition—and perhaps a value pattern—and made some thumbnail sketches, make a more de-

tailed sketch, if you like. For this, there's no need to add values.

Then, transfer your sketch to your watercolor paper. A light pencil sketch is enough to place your chosen objects on the page. Transfer this freehand, or if you prefer, make a grid of your sketch by dividing it into rough thirds both ways—vertically and horizontally. Draw those lines *lightly* on your watercolor paper, then transfer what you see in each section. Don't ask me why, but breaking it down into bite-sized pieces sometimes makes the transition easier.

These are guidelines, not rules, in any case. Many people do fine without preplanning, and lots of people paint darks first in order to key their other values. Still others never paint large shapes at all, but do a pointillist

> ## TIP
>
> *A hardbound sketchbook will withstand the rigors of drawing outdoors much better than a spiral-bound one. I've dropped mine down a cliff with no ill effects!*

handling of hundreds of small dots.

Most often with watercolor, you paint light-to-dark and large-to-small. If you want to have small whites or lights left at the end, you'll need to plan for them. Paint around them or protect them with liquid mask or masking tape. (There are ways to reclaim lights, which we'll cover in a bit, but planning ahead saves you a possible panicky moment or two.)

87

Your First Landscape

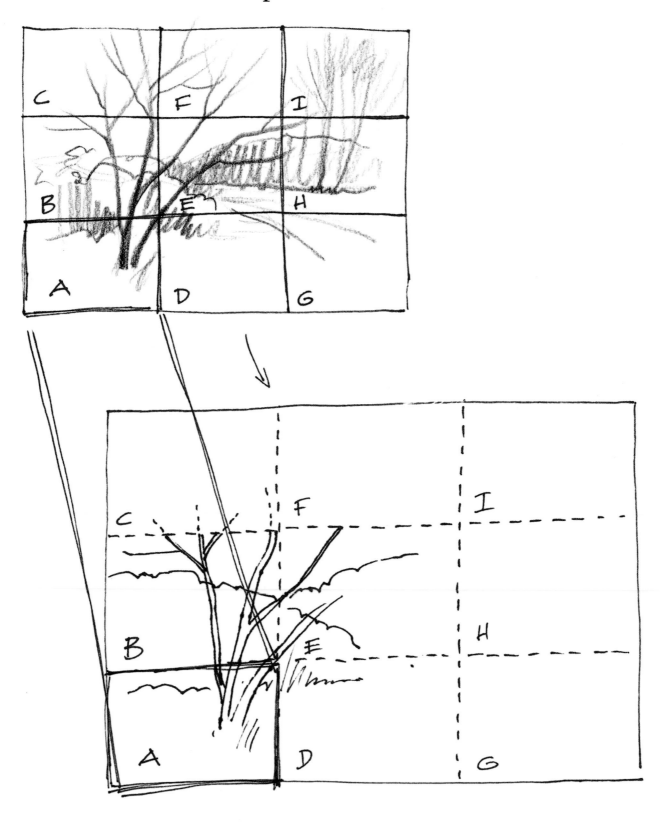

Your First Landscape

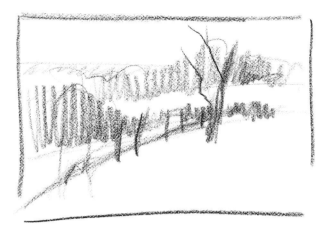

rough sketch

Mask out tree
and fence posts

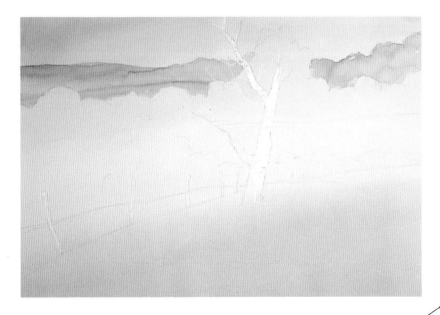

1.

Lay in a graded
(or variegated)
wash over the
whole painting
area when mask
is dry.

A 2"
brush is
good
for
this

This wash should be bluer and cooler
in the sky area, then warmer where the grassy
fields are to be. When dry, lay in the distant
trees with a bluish green — very light.

2.

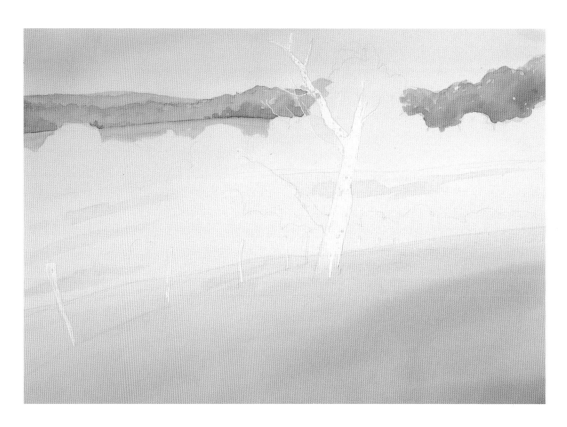

Let everything dry thoroughly (that's the trick to controlling watercolor, in a large degree), then add the next line of trees – go a bit darker and a bit greener. Make the upper edge varied→ to suggest foliage.

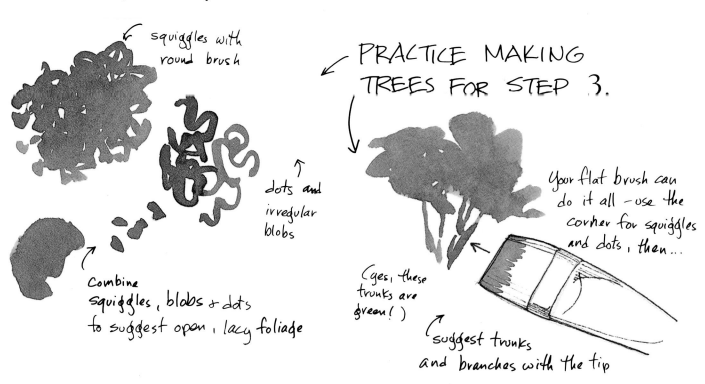

squiggles with round brush

dots and irregular blobs

Combine squiggles, blobs & dots to suggest open, lacy foliage

PRACTICE MAKING TREES FOR STEP 3.

Your flat brush can do it all – use the corner for squiggles and dots, then...

(yes, these trunks are green!)

suggest trunks and branches with the tip

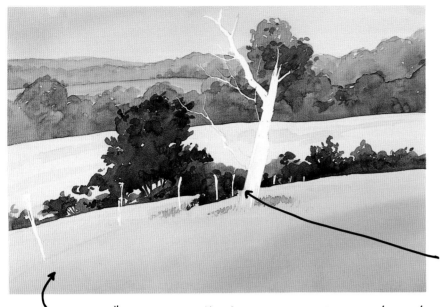

3. — Put those dots and squiggles to work — now your color is darker and greener still as you move into the foreground.

Let everything dry and remove the masking agent.

trunks, etc., with tip of flat

add another wash in the foreground if it looks too pale

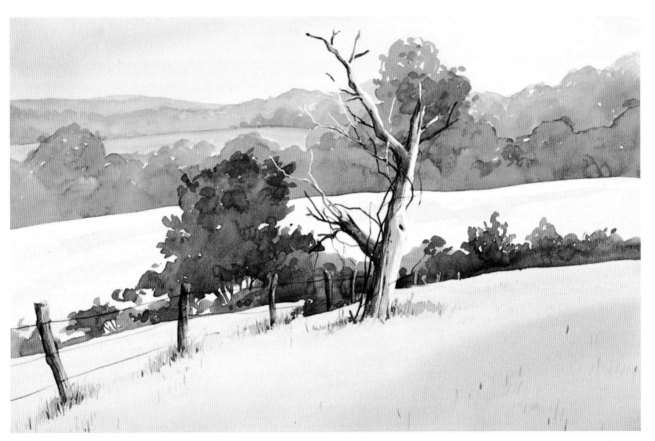

4. — Now paint in the tree and fenceposts, first laying in larger washes and letting them dry. Leave a little white paper on the light-struck side. Then add small, sharp details.

burnt sienna

ultramarine

I used these colors:

burnt umber

Seasonal Palettes

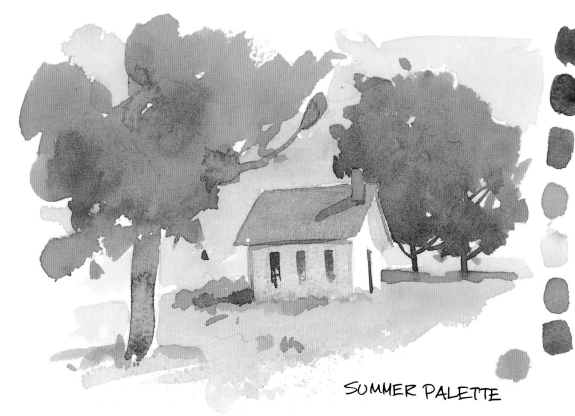

summer can get by with more colors or fewer — the landscape on the previous page is more subtle

SUMMER PALETTE

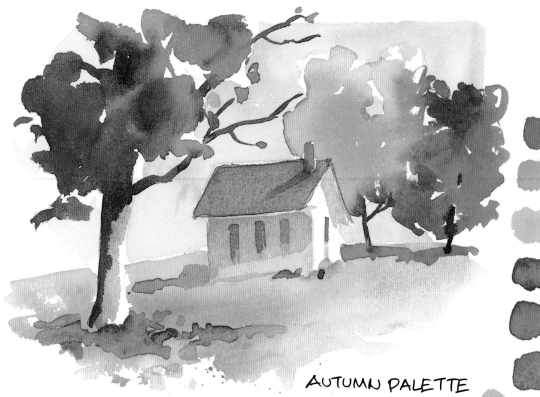

autumn is colorful, but don't get carried away

AUTUMN PALETTE

CHOOSE YOUR PALETTE OF COLORS ACCORDING
TO THE SEASON TO CAPTURE THE PROPER FEELING

Seasonal Palettes

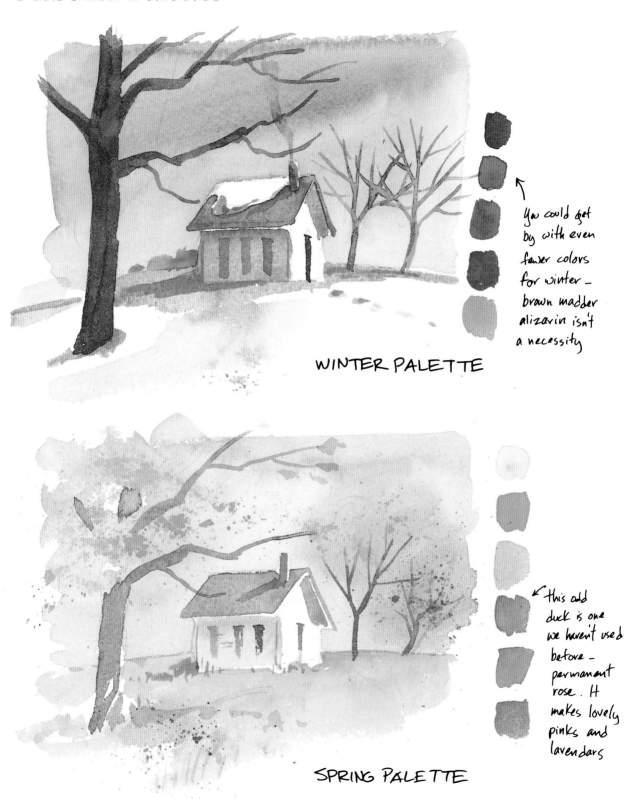

You could get by with even fewer colors for winter — brown madder alizarin isn't a necessity

WINTER PALETTE

this old duck is one we haven't used before — permanent rose. It makes lovely pinks and lavendars

SPRING PALETTE

Use a Limited Palette

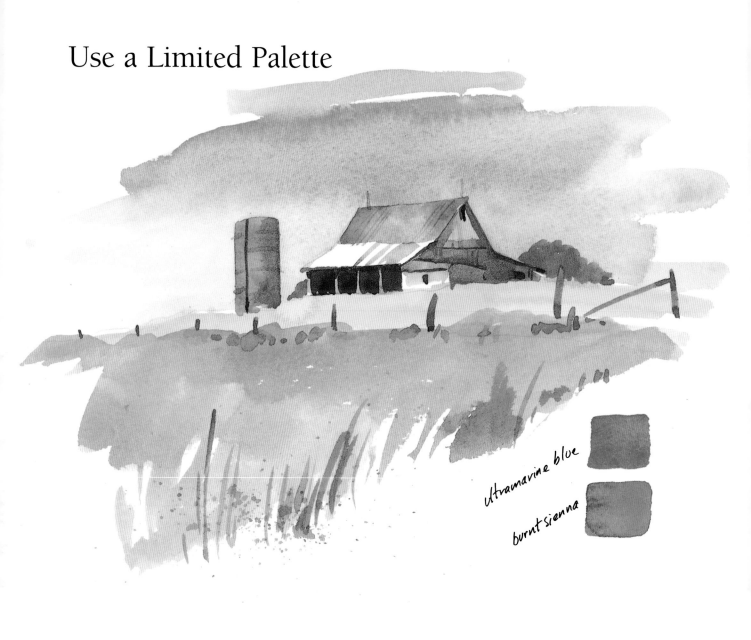

ultramarine blue

burnt sienna

Use two colors (mixed in various combinations) or branch out into three or four.

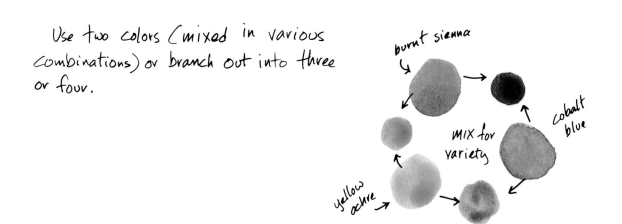

burnt sienna

cobalt blue

MIX for variety

yellow ochre

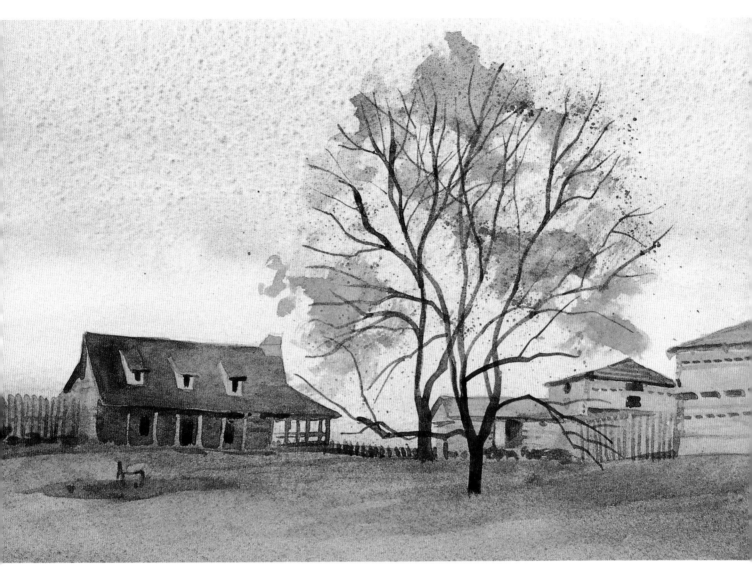

Fort at Dusk

This can be a simplified picture, just to explore foliage, trunks and branches—there's no need to worry about horizon lines, backgrounds and foregrounds every time.

This is a good place to enjoy your colors. Those at left were all used in our demonstration.

A Fall Scene

burnt
umber

yellow
ochre

raw
sienna

burnt
sienna

brown
madder
alizarin

alizarin
crimson

cadmium
orange

cadmium
yellow
medium

Cadmium
yellow
light

Antwerp
blue

ultramarine
blue

1. Plan foliage shapes and sky — remember to vary sizes and shapes for interest. Sketch them on your paper and lay in first washes. Let dry and add sky.

wet-in-wet

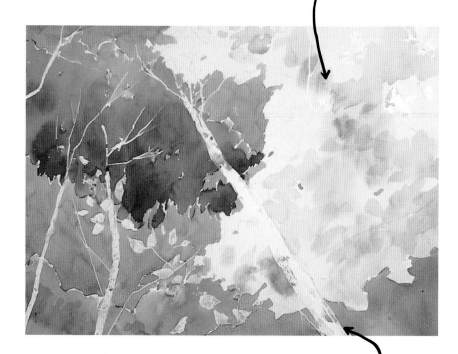

masked trunks & twigs

2.

When the sky wash is dry, add more (and darker) foliage. Remove mask and lay in first washes on trunks and branches

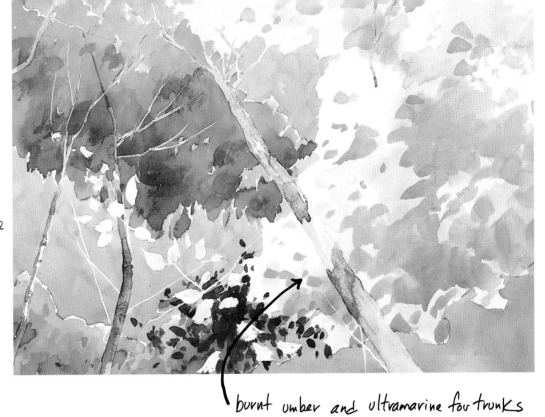

burnt umber and ultramarine for trunks

3. Let dry and come back in with fine, dark details

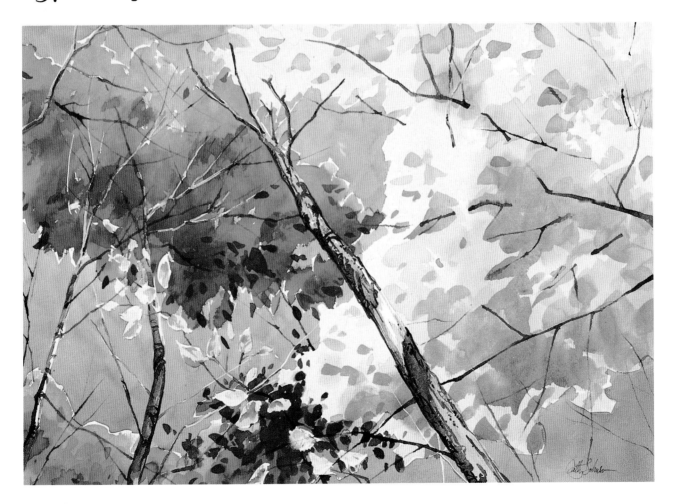

A Winter Scene

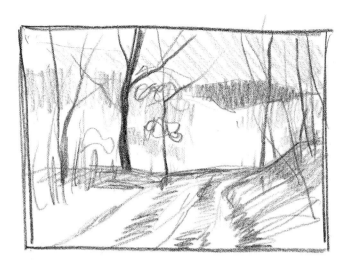

Thalo blue Alizarin Crim. Cadmium Yellow Light

fan brush "trees"

1.— Wet your paper with clear water, then drop in the primaries in pale washes. Run a brush through them to mix on your paper, or tilt painting. Wet-in-wet in a darker shade suggests distant hills, shadows.

ultramarine blue shadows

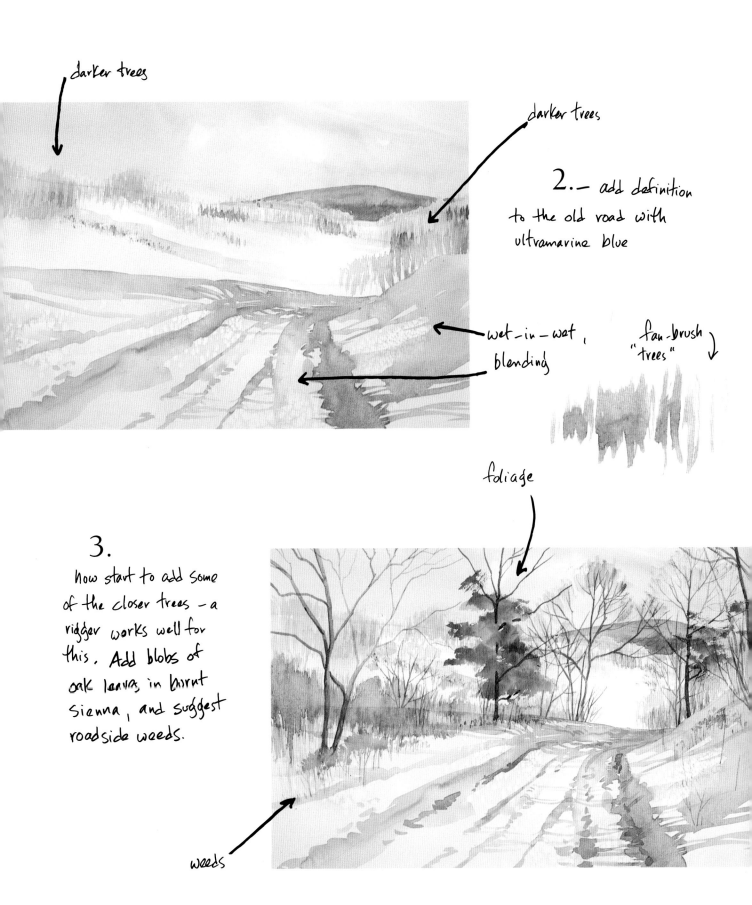

darker trees

darker trees

2.— add definition to the old road with ultramarine blue

wet-in-wet, blending

fan-brush "trees"

foliage

3.

now start to add some of the closer trees — a rigger works well for this. Add blobs of oak leaves in burnt sienna, and suggest roadside weeds.

weeds

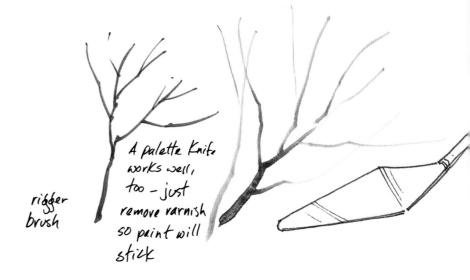

ridger brush

A palette Knife works well, too - just remove varnish so paint will stick

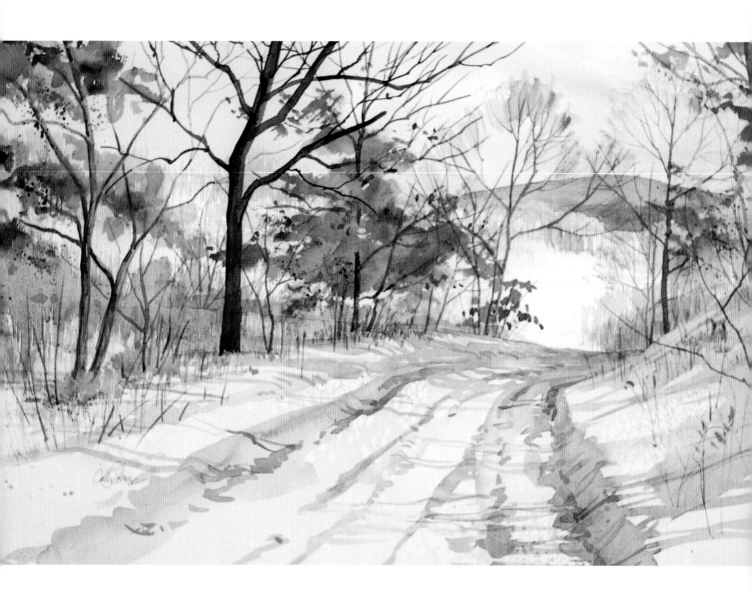

4. – Finish up with small twigs and branches, bits of foliage, shadows and other details.

Farm Scene

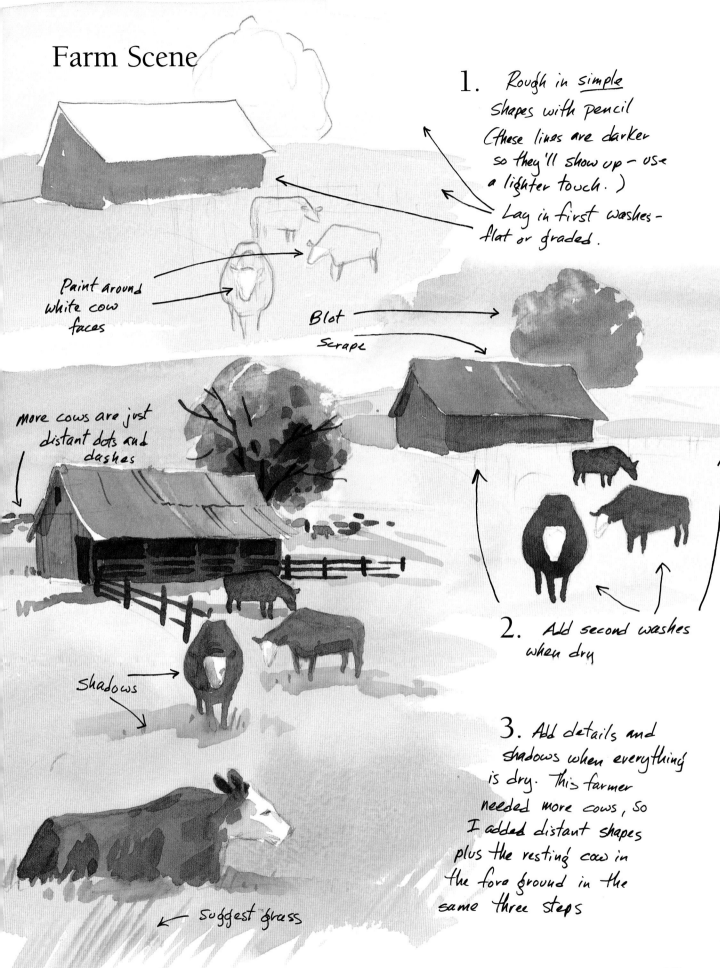

1. Rough in simple shapes with pencil (these lines are darker so they'll show up - use a lighter touch.) Lay in first washes - flat or graded.

Paint around white cow faces

Blot

Scrape

More cows are just distant dots and dashes

Shadows

suggest grass

2. Add second washes when dry

3. Add details and shadows when everything is dry. This farmer needed more cows, so I added distant shapes plus the resting cow in the fore ground in the same three steps

Barn Scene

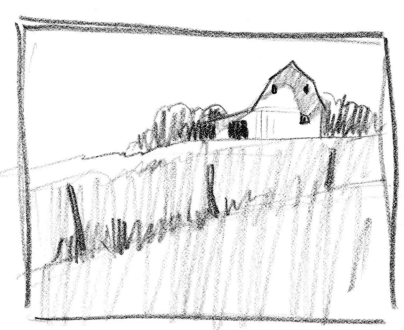

Explore the basics of format – how would this particular scene look best? A vertical format is more dramatic, usually, and a horizontal one more pastoral and restful

horizontal?

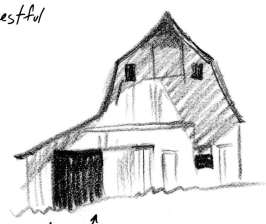

detail ↗

or vertical?

Wet-in-wet trees

wet-in-wet trees

1. – It isn't always necessary to mask out things you want to stay white. This barn was a simple shape, and easy to paint around. Trees can blend into sky if painted wet-in-wet.

2.

Lay in the middle- and foreground with a big flat brush (1" or bigger). While this wash is damp, add weeds and rough grass. Scrape through for light highlights. Lay in shadow on barn, and use a bit of burnt sienna for reflected light in the peak. _Let dry._

shadows and reflected light

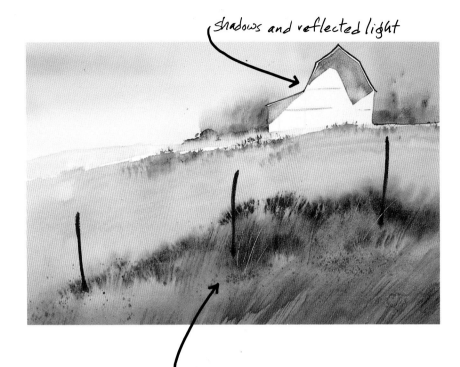

scraping, spatter, fan brush

details

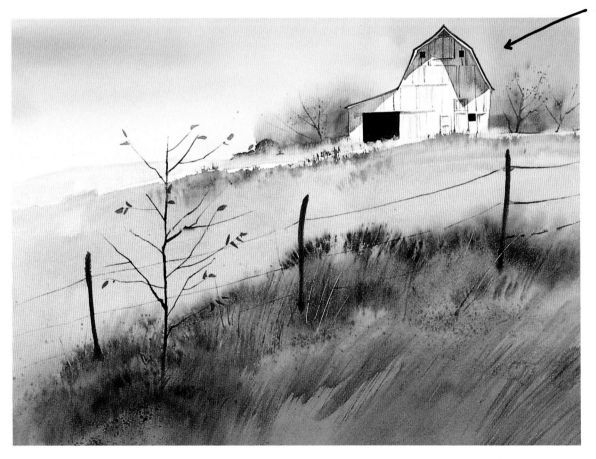

3. — Add small, sharp details to barn and foreground. The little tree helps balance the barn. A rigger brush works well for the fence wire.

Snowy Farm Scene

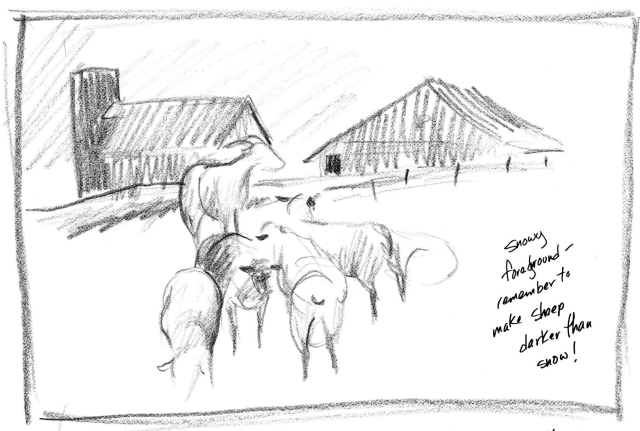

Snowy foreground — remember to make sheep darker than snow!

Feel free to borrow from several sources or to rearrange what you have. Change seasons or time of day — change the format and the color scheme. Create! You're the artist

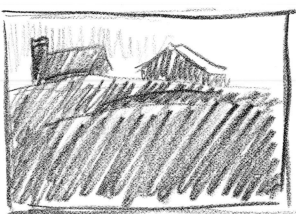

My original resources were a summer scene with sheep & goat (a vertical format) and a dark, stormy spring scene of the two barns — a horizontal. I put them together and made a late-spring snowstorm.

blot

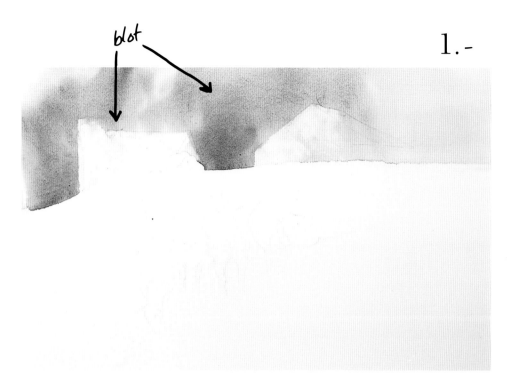

1.-

Lay in a nice, storing sky, wet-in-wet. This time, instead of painting around the barns, just lift some of the paint with a folded paper towel.

A warm dark brown suggest distant trees.

2. - Try a ½" or ¾" flat brush to lay in the barns. Do the roofs first, let them dry, then paint the rest. Use liquid mask to protect the upper edge of the goat.

A little cool blue acts as foreground show (no prismatic effect this time - it's storming.)

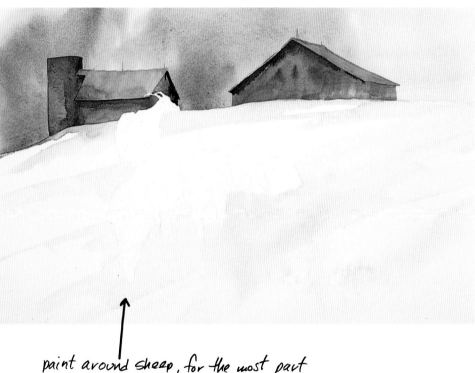

paint around sheep, for the most part

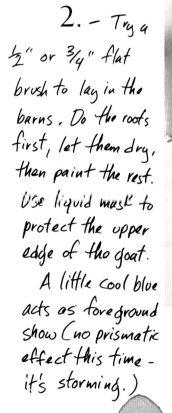

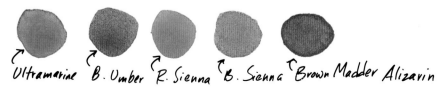

↑ Antwerp ↑ Ultramarine ↑ B. Umber ↑ R. Sienna ↑ B. Sienna ↑ Brown Madder Alizarin

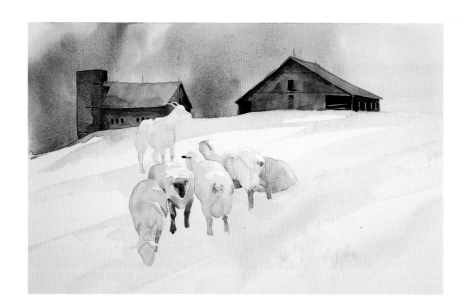

When thoroughly dry, add details to the barns.

Remove liquid mask and lay in first washes on the sheep and goats. Paint them one at a time, with variegated and wet-in-wet washes.

Darker color suggests detail in faces & legs — wet-in-wet, again.

spatter with stencil brush

4. — When dry, add details to animals, fence posts, shadows & grain. Let dry again and spatter with <u>opaque</u> white for falling snow.

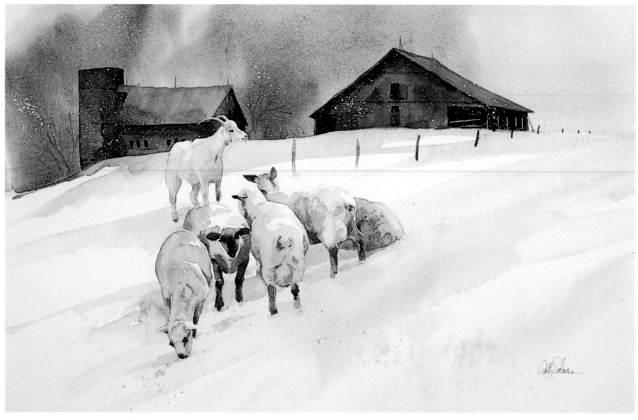

Boat Scene

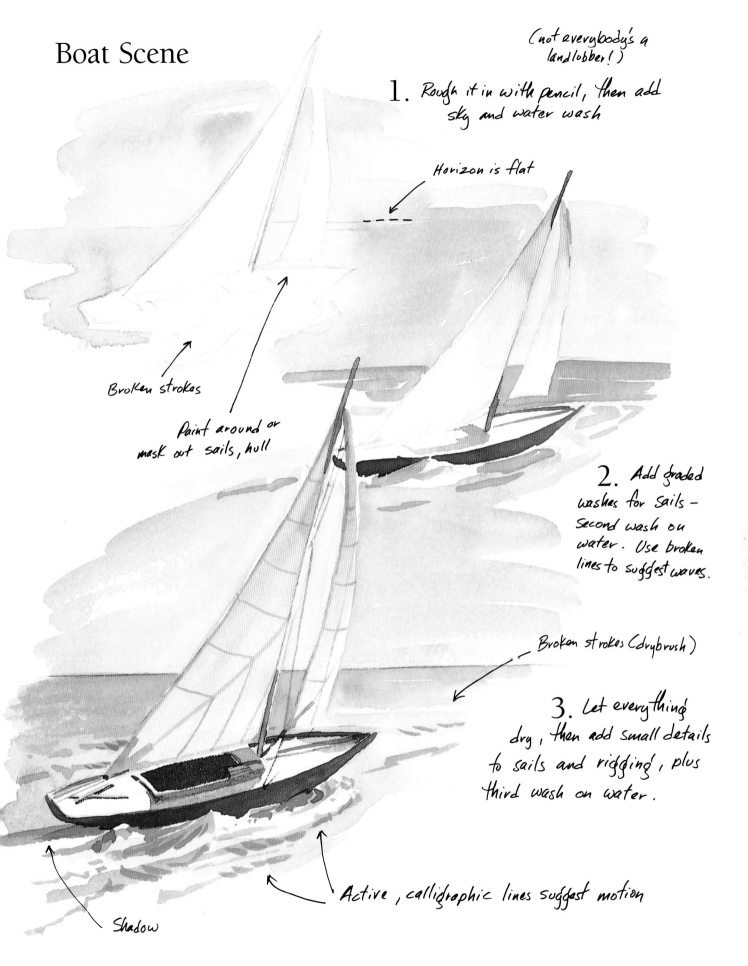

(not everybody's a landlobber!)

1. Rough it in with pencil, then add sky and water wash

Horizon is flat

Broken strokes

Paint around or mask out sails, hull

2. Add graded washes for sails — second wash on water. Use broken lines to suggest waves.

Broken strokes (drybrush)

3. Let everything dry, then add small details to sails and rigging, plus third wash on water.

Active, calligraphic lines suggest motion

Shadow

Planning Your First Still Life

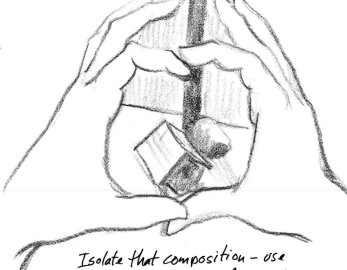

Oops — I realized I had put the edge of the deck right in the middle of my picture. I moved the top of my picture down a bit, as shown.

Extreme vertical — dark

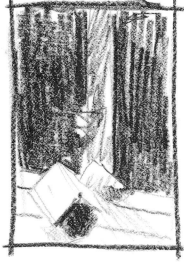

Still lifes are very satisfying. We feel somehow more in control, whether we set up the items to paint or "find" a ready-made still life.

Isolate that composition — use your hands as a "viewfinder."

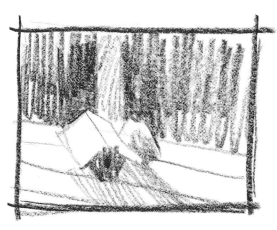

Horizontal Composition

If you have trouble "seeing" the proper angles, line up your pencil along the roofline. Transfer that same angle to your watercolor paper.

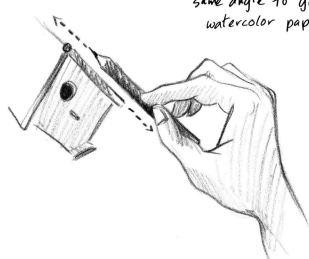

1. (right) — Using liquid mask, mask out leaves and vines you want to protect. Paint in the post and the first wash on the bird house, wet-in-wet to suggest shadows.

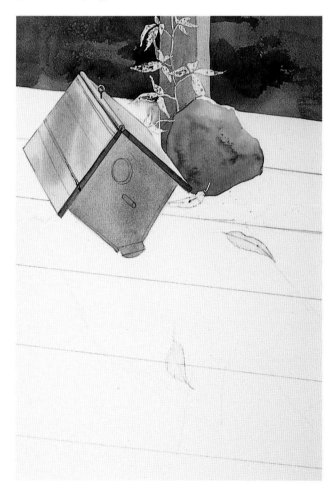

2. (left) — When everything is dry, add a variegated wash for background foliage and the first wash on the rock. Use a variegated wash here, too. Blot for texture, if you like. (By the way, the real bird house was a dull brown.)

Br. Madder Alizarin

Cobalt Blue

Burnt Sienna

Sap Green

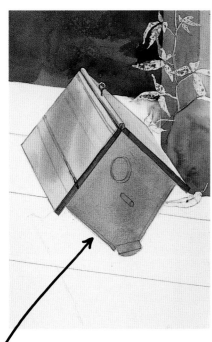

← Detail: In this close-up view of Step 2, you can see the second washes on the bird house and the variegated washes in the background and granite rock

wet-in-wet, backruns

• Now, we've added:

raw sienna

burnt umber

ultramarine blue

add burnt sienna to cobalt blue for reflected light

3. — Now, add a light wash of very diluted burnt umber and raw sienna for the deck — lots of water and only a little pigment.

While it's wet, add ultramarine blue (also pale) for shadows.

Add detail in bird house and rock.

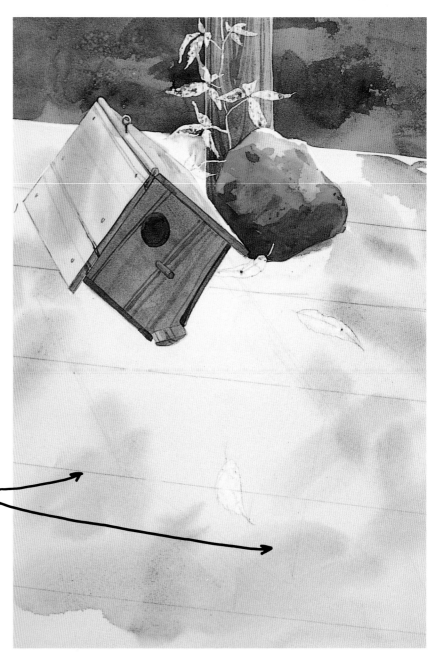

wet-in-wet shadows

4. — Now, mix burnt umber and ultramarine blue for the darker, more distinct shadows of the bird-house, rock and pole.

Remove liquid mask when everything is completely dry.

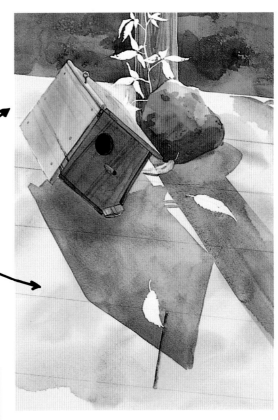

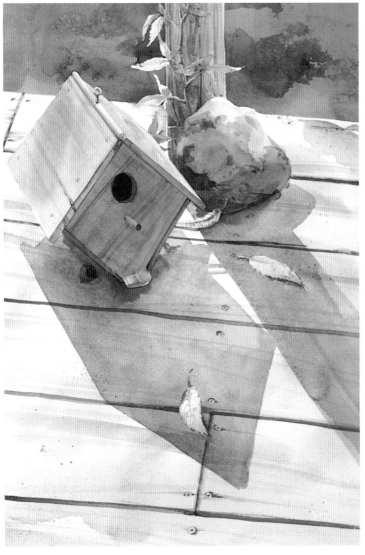

5. — Finish up with details of leaves, rock and birdhouse. Paint lines to indicate boards of the deck, and suggest their texture.

Finally, we've added

Cadmium yellow light

cadmium orange

to our palette.

Dolls and Toys

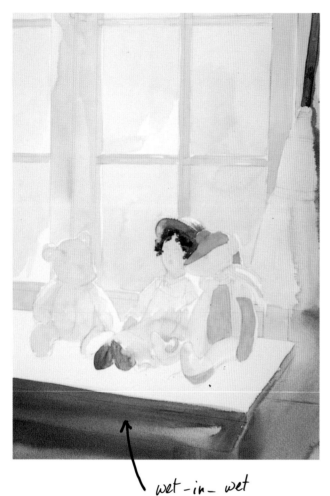

wet-in-wet

Painting these charming subjects is just like painting a still-life - you can choose what you like and arrange your subjects any way you want.

1. - Draw your composition on your watercolor paper, then add light washes of the colors you've chosen. Remember, the light outside looks very pale from indoors.

painted wood trim much darker than outdoors

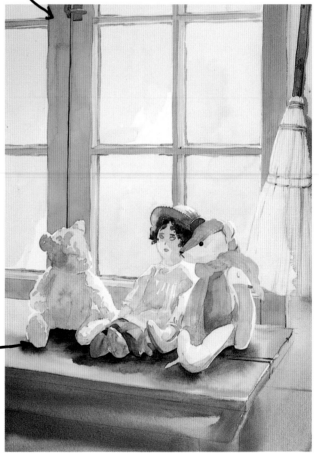

2. - When these first washes are dry, begin to model forms using a darker value.

Begin to paint the details of window, broom, dolls and bears. (My old blue bear has no eyes - add black dots, if you like.)

Darker shadows beneath doll & bears

"Plaid"—print lines one way, let dry, & paint lines the other direction.

Squiggles make fake fur.

← bandanna

Put down a permanent rose wash—let dry and add pattern.

3. — Finish up by adding details to fabric and fake fur. See our suggestions, above, or make up your own.

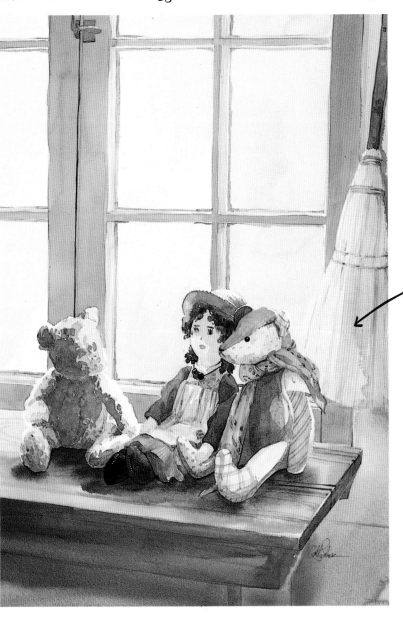

"Fur"
"Fur" is painted in several layers — let dry between each layer

Let design of fabric follow folds or roundness of form.

Painting Flowers

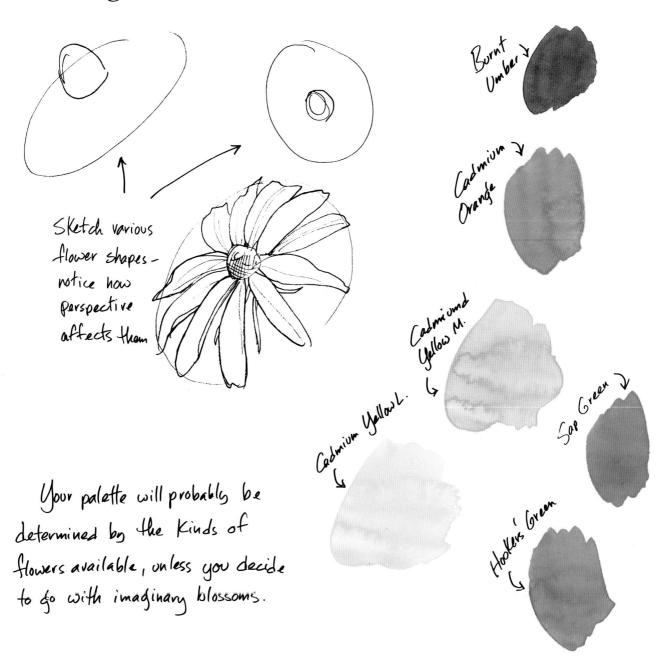

Sketch various flower shapes—notice how perspective affects them

Burnt Umber ↓

Cadmium Orange ↓

Cadmium Yellow M. ↓

Cadmium Yellow L. ↓

Sap Green ↓

Hooker's Green ↓

Your palette will probably be determined by the kinds of flowers available, unless you decide to go with imaginary blossoms.

Painting flowers is fun any time of the year. When your garden's not in bloom, the florist's is. I chose black-eyed Susans, which bloom wild along my road.

Practice Strokes for Flower Painting

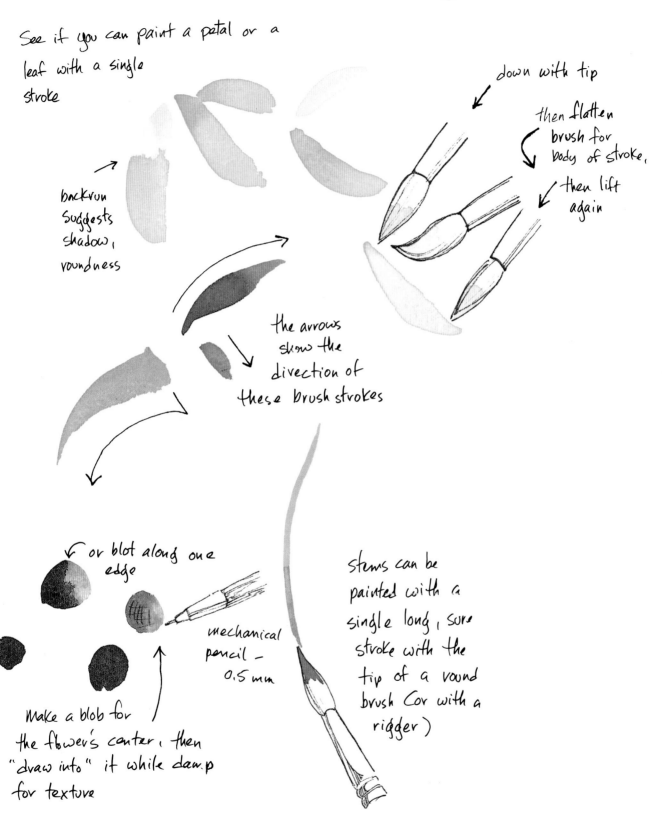

See if you can paint a petal or a leaf with a single stroke

backrun suggests shadow, roundness

down with tip

then flatten brush for body of stroke,

then lift again

the arrows show the direction of these brush strokes

or blot along one edge

mechanical pencil — 0.5 mm

Make a blob for the flower's center, then "draw into" it while damp for texture

Stems can be painted with a single long, sure stroke with the tip of a round brush (or with a rigger)

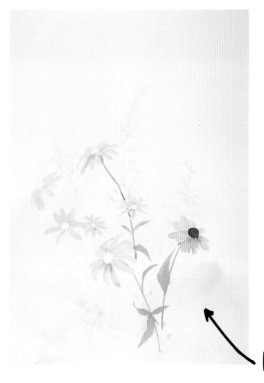

1.

Plan your composition and transfer it to your paper. Mask out areas you don't want to be affected by the background washes – for instance, the color of the blue flowers will stay fresher and clearer if they're not sullied with yellow.

Wet your paper thoroughly and splash in a background wash. Let dry and add first flower shapes.

background wash is cadmium yellow light and sap green

Detail: Notice how flower shapes are a combination of the strokes you practiced.

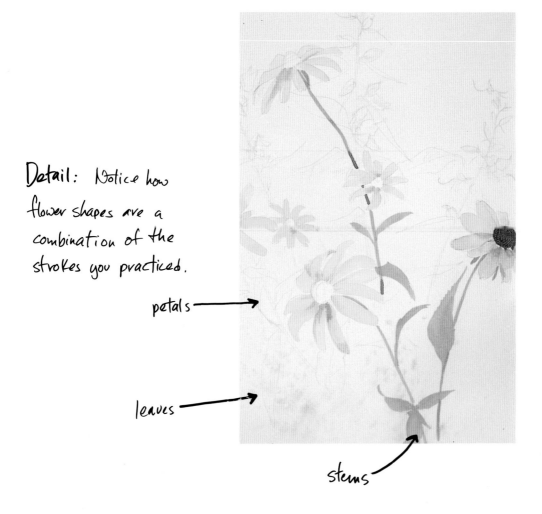

petals →

leaves →

stems

2. — Remove liquid mask and paint in blue flowers — notice that upper buds are a combination of blue and a very light sap green.

Add leaves and stems — I used sap green for the yellow flowers and Hooker's Green for blue ones.

Permanent Rose

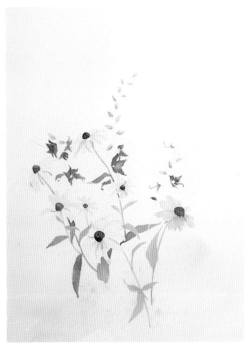

Ultra-marine Blue

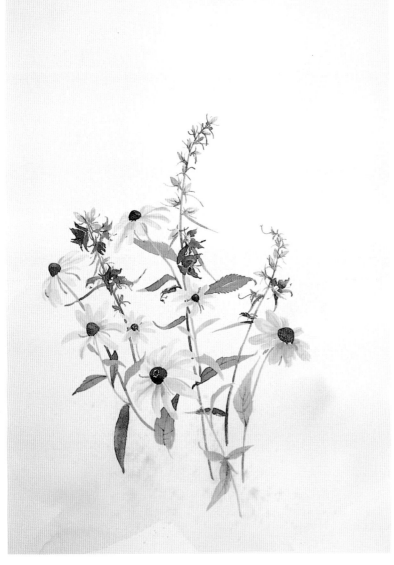

3. — Finish up with details after first and second washes dry.

Mixing Watercolor and Colored Pencil

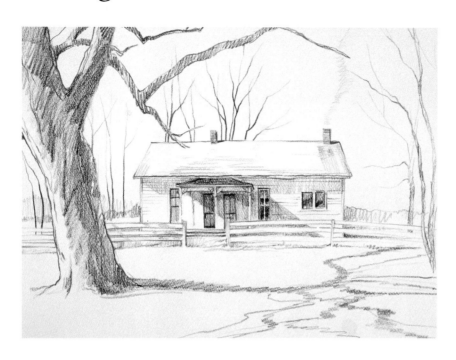

You can use lots of pencils, or just one. I use black or a warm dark gray. This is an <u>old</u> technique, and one that gets you past some of the anxiety of watercolor.

1. — Make a drawing with just a bit of an indication of value in the shadows. This is black Prismacolor on cold-press watercolor paper.

2. — Lay in loose washes, staying somewhat in the lines — just like when you were a kid, except <u>you</u> did the original drawing.

Do the grass, roof and shadows first.

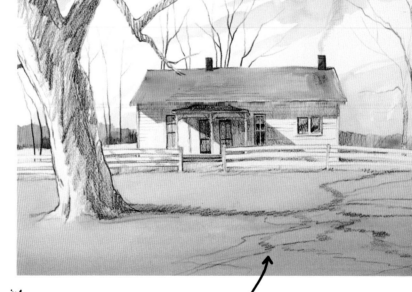

darker foreground — graded wash

raw sienna

burnt sienna

ultramarine blue

3. — When those washes are dry, add trees, windows and so forth.

Use a wet-in-wet technique on the tree to suggest light and shadow

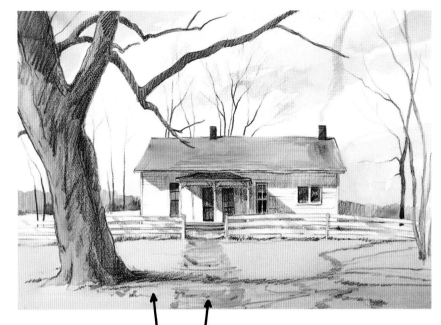

start with burnt umber →

← add more + more blue

add path and dead leaves

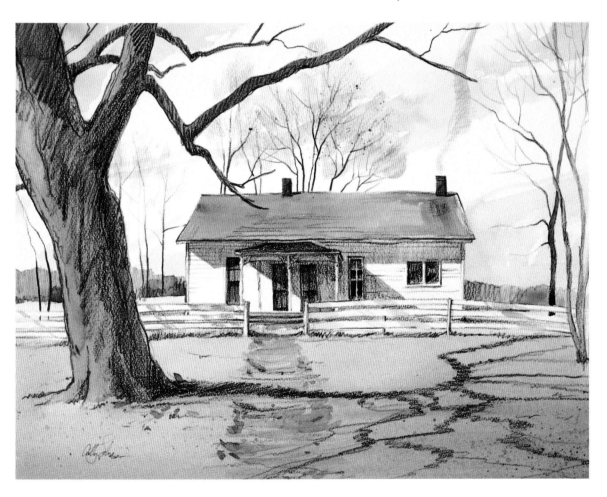

4. — A few quick details like the suggestion of twigs on the far trees and a bit of spatter, and you're done!

Bibliography

As you progress, books can be your best friends, urging you to grow and change and learn—but letting you do it at your own pace and in the privacy of your own studio. When I first started with watercolor, I pored over John Pike's and Herb Olson's books—along with many others. Non-instructional art books can be great, too. I loved to turn the pages in any book that showcased Winslow Homer or Fairfield Porter.

Books are good idea-starters and problem-solvers—and, if the writer remembers what it's like getting started with watercolor, they can be the best teachers you'll ever have. Here are some I recommend, from beginner's manuals to more advanced stuff. You'll be ready for them soon enough.

Albert, Greg and Rachel Wolf, editors. *Basic Watercolor Techniques*; Cincinnati, North Light Books, 1991.

Couch, Tony. *Watercolor: You Can Do It!*; Cincinnati, North Light Books, 1987.

Daly, Thomas Aquinas. *Painting Nature's Quiet Places*; New York, Watson-Guptill Publications, 1985.

Johnson, Cathy. *Painting Nature's Details in Watercolor*; Cincinnati, North Light Books, l987. A watercolor-oriented study of nature.

———. *Drawing and Painting from Nature*; New York, Design Press, a subsidiary of Tab Books. Covers painting, drawing, old masters and new.

———. *Watercolor Tricks and Techniques*; Cincinnati, North Light Books, 1992.

———. *Creating Textures in Watercolor*; Cincinnati, North Light Books, 1992.

———. *Sierra Club Guide to Sketching in Nature*; San Francisco, Sierra Club Books, 1991.

Millard, David. *The Joy of Watercolor*; New York, Watson-Guptill Publications, 1983.

Nofer, Frank. *How to Make Watercolor Work for You*; Cincinnati, North Light Books, 1991.

Pike, John. *John Pike Paints Watercolor*; New York, Watson-Guptill Publications, 1978. An oldie but goodie.

Shapiro, Irving. *How to Make a Painting*; New York, Watson-Guptill Publications, 1985.

Index

More Great Books
for Beautiful Watercolors!